IMAGES
of America

SMITH MOUNTAIN DAM AND LAKE

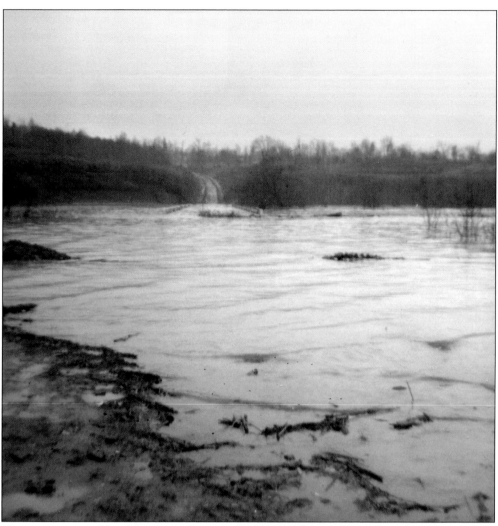

The construction of Smith Mountain Dam resulted in the filling and formation of Smith Mountain Lake over a period of approximately three years. In the photograph above, part of the old Hales Ford Bridge comes to an abrupt end and will soon be covered by the rising waters of the new lake. (Courtesy of Stephanie Lawson.)

ON THE COVER: The familiar curved face of Smith Mountain Dam holds back the waters of Smith Mountain Lake, creating one of the most popular recreation areas in the commonwealth of Virginia. Smith Mountain is said to have been named for two brothers who settled there in 1740, Daniel and Gideon Smith. (Author's collection.)

IMAGES
of America

SMITH MOUNTAIN
DAM AND LAKE

To Rick –
Hope you enjoy!
Best wishes,
James Nagy

James A. Nagy

ARCADIA
PUBLISHING

Published by Arcadia Publishing
Charleston, South Carolina

Printed in the United States of America

Library of Congress Control Number: 2014940241

For all general information, please contact Arcadia Publishing:
Telephone 843-853-2070
Fax 843-853-0044
E-mail sales@arcadiapublishing.com
For customer service and orders:
Toll-Free 1-888-313-2665

Visit us on the Internet at www.arcadiapublishing.com

*To my wife, Jill, and in honor of Earle T. Snodgrass,
who oversaw the Smith Mountain Project*

CONTENTS

ACKNOWLEDGMENTS

When Arcadia Publishing asked me to do another book, I was both excited and apprehensive. My experience with writing Images of America: *Franklin County*, while very enjoyable and gratifying, opened my eyes to the hard work required to produce a quality book—even one consisting primarily of images and captions. As with my previous work, it helped to have the assistance and support of several people in putting together this volume on Smith Mountain Dam and Lake.

The majority of images in this book were obtained from the archives of American Electric Power (AEP), which is the parent company of Appalachian Power Company (APCO). I would like to give thanks to AEP's John Shepelwich for making it possible for me to scan images from the company's extensive collection of pictures dating back to the early 1960s. Thanks also to my technical advisor and friend, hydromechanic Darrell Powell, whose knowledge of the Smith Mountain Project and assistance with helping me understand some of the technical aspects of the pump storage process were invaluable.

Special thanks is also due to Diane Barbour for allowing me to use photographs of her family, who were the owners of the area where the dam now sits and sold the property to APCO. Thanks also to Nathan Flinchum, Virginia Room librarian for the Roanoke Public Library system, for the research he performed in locating articles related to Smith Mountain Dam and Lake.

The hospitality of Alice Swain and Amanda Thompson in permitting me to include images and the story of *Virginia Dare* Cruises & Marina is also much appreciated. Thanks to Jerome Parnell III for the same hospitality regarding his business, Sunken City Brewing Company. Theirs are just two examples of successful lake area businesses built with pride and hard work.

Finally, a base support system is imperative in such an undertaking as this, and I wish to thank my wife, Jill, for her continued encouragement. I also appreciate the contributions and support I received from J.D. Abshire, Cindy McCall Cundiff, Dorothy Cundiff, Randy Stow, Sarah Thomason, Belinda Wray Webb, and Patricia Wessner.

INTRODUCTION

Smith Mountain Dam is an impressive example of man's ability to harness and employ one of nature's most powerful forces—water. The idea to build a dam in the gap at Smith Mountain in Pittsylvania and Bedford Counties, Virginia, first occurred in the 1920s but was not brought to fruition until the early 1960s. Since then, a lot of water has passed over the dam, or to be more accurate, through the dam. The power plant at Smith Mountain Dam currently has the capacity to produce 605 megawatts of electricity for up to 11 hours and is used to meet peak periods of energy requirements in the American Electric Power (AEP) system. The dam at Smith Mountain is not the largest dam in the United States, but it is still a testament to the power of engineering and hard labor. It is the author's hope that the reader will gain a knowledge and appreciation of the hard work and ingenuity it took to make Smith Mountain Dam and Lake a reality.

Any story of the mechanics of what is known as the Smith Mountain Project would not be complete without the inclusion of the Leesville Dam. The Leesville Dam was built in conjunction with the dam at Smith Mountain and the two dams work as concrete teammates in the production of hydroelectricity. Electricity is produced when water passes through the turbine generators of Smith Mountain Dam, and it then travels downstream to Leesville Lake. Leesville Dam enables AEP to store the water until it needs to be pulled back upstream for reuse. Although smaller than its sister dam, the Leesville Dam is an integral part of the Smith Mountain Project and allows the process to work as a whole.

Before the white man ever came to the area, Native Americans hunted in the game-filled woods and caught fish in the flowing waters of the local river. Some of the oldest artifacts created by humans in Virginia were found during excavations at the Leesville Dam. The first white visitors to the region came in 1670 and discovered the river, which the Saponi tribe called "Rorenock" and which is now known as the Roanoke River. The expedition, led by John Lederer, followed the river from near present-day Altavista toward Leesville. In 1671, an expedition led by Abraham Wood again followed the Roanoke River northwest but continued on through the gap at Smith Mountain and eventually made it to a Totero village near present-day Roanoke. During the construction of Smith Mountain Dam, archaeologists found evidence that members of the Algonquin tribe fished and hunted in the area of the gap.

Today, visitors to Smith Mountain still enjoy the natural beauty of the area that those early explorers experienced. Now, however, there is a man-made aspect, which also impresses modern travelers. Those folks who visit Smith Mountain Dam come away with a sense of awe, not only because of the size of the structure, but also because they are aware of the vast amount of water held back by the concrete barrier. Water rushing away from the dam during generation is a sight worth seeing and makes the operation of the facility even more impressive. Almost since the day Smith Mountain Lake reached full capacity, there have been rumors of catfish the size of cars seen by divers near the base of the dam. Although no evidence has ever been produced, giant catfish make for a great story and add a sense of mystery to what lies beneath the water of the lake. The history of the construction of the dam and lake is an even more captivating tale.

Many people wonder what the area behind Smith Mountain Dam looked like in the years just before the lake covered the landscape. However, attempts to locate images from the pre-dam period proved to be difficult. Most of the area was farmland or woods, and photographs are hard to come by. However, the reader will get glimpses of what the area was like as the lake slowly filled from some of the early photographs in this volume. Also of interest are the adjustments in the local roads and bridges that had to be made in anticipation of a lake forming where only rivers and streams had been before.

Smith Mountain Lake is one of the most popular recreational areas in the state of Virginia and the commonwealth's second-largest freshwater lake. Visitors and residents alike enjoy boating, water skiing, jet skiing, and swimming as well as fishing and just relaxing in the warm Virginia sun. As the lake has increased in popularity over the years, so have lakefront residential communities. This has led to commercial development around the lake to support these communities and diverse shopping and dining opportunities.

It is interesting to speculate on what became of some of the structures that were left on what was to become the bottom of the lake. It is assumed that any structures that were not removed prior to the lake's creation have long since collapsed under the pressure of the water. However, in 2009, Rocky Mount real estate broker J.D. Abshire captured sonar images of remnants of the submerged old Hales Ford Bridge. His discovery even surprised AEP officials, who had previously found no evidence of the old bridge during bathymetry readings, which were used to map the floor of the lake.

On the north shore of Smith Mountain Lake in Bedford County lies Smith Mountain Lake State Park. Visitors to the park can take advantage of swimming, boat rentals, picnicking, camping, a fishing pier, hiking trails, and rental cabins. The natural beauty of the area around Smith Mountain Lake as well as the available outdoor activities make it a desirable vacation destination. Even Hollywood has taken notice of the aesthetically pleasing quality of the Smith Mountain Lake area as the motion picture *What About Bob?* was filmed there in 1991. The comedic film starred Bill Murray and Richard Dreyfuss. In addition, a 2012 Hallmark Channel movie, *Lake Effects*, was shot at the lake and starred Jane Seymour, Scottie Thompson, and Madeline Zima.

One does not have to travel far from the lake to get a sense of history, as the nearby Booker T. Washington National Monument transports visitors back in time to the mid-17th century. The former Burroughs Plantation was the Franklin County birthplace of the famous African American educator, and the National Park Service maintains the monument as a tribute to Washington's rise from slavery. Visitors can tour the plantation site and learn firsthand of what life was like on a rural farm during the years leading up to the end of the Civil War. It would be interesting to know what people from that time would think of Smith Mountain today. No doubt they would be as impressed as modern-day visitors.

One

BEFORE THE DAM

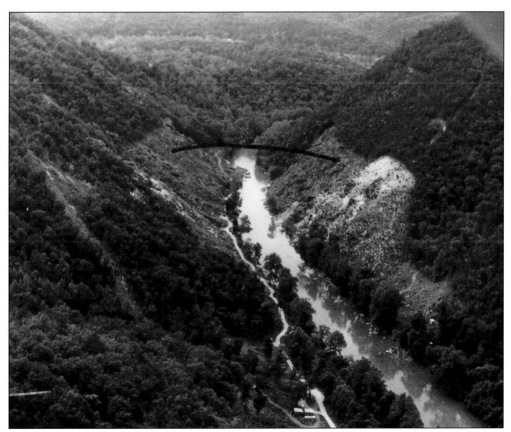

As early as the 1920s, the Appalachian Power Company (APCO) was considering the construction of a dam on the Roanoke River in the gap of Smith Mountain between Pittsylvania and Bedford Counties, Virginia. Shown here is an undated aerial photograph of the gap in the mountain. An unknown artist has drawn an arched line to indicate the approximate location of the future dam. (Courtesy of Dorothy Cundiff.)

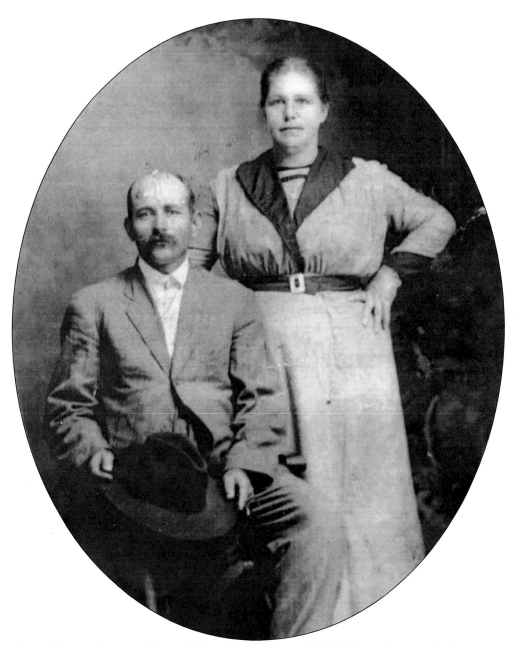

Pictured here in the early 1900s are Walter Daniel Barbour (1868–1919) and his wife, Gilley Arthur Barbour (1866–1927). Barbour was a farmer and lived with his wife and their nine children in a home in the northwest corner of Pittsylvania County. He owned over 350 acres of land on which Smith Mountain Dam and parts of Smith Mountain and Leesville Lakes are now located. After Barbour passed away, four of his sons, Curgie, Tom, Esker, and Otha, bought the land from their mother. Gilley continued to live in the farmhouse with Tom and his wife, Birdie, until Gilley passed away. Esker eventually sold his interest in the farm to Tom and moved to Roanoke. Tom, Curgie, and Otha later sold the property to APCO for use in the Smith Mountain Project. The original homestead burned in 1931, and Tom Barbour built the house that can be seen today at the foot of the gap. (Courtesy of Diane Barbour.)

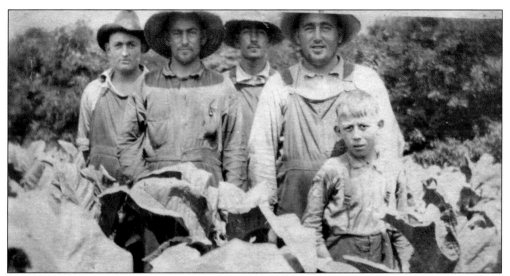

Most of the developed land in the Smith Mountain area was devoted to agriculture, meaning family farms and homesteads. Historically, one of Virginia's main cash crops has been tobacco. In this photograph are, from left to right, brothers Roosevelt (1904–1968), Otha (1890–1966), Quitman "Tom" (1896–1964), and Esker "Eck" Barbour (1894–1950), along with their cousin Herman Barbour, standing in waist-high tobacco in the late 1930s. (Courtesy of Diane Barbour.)

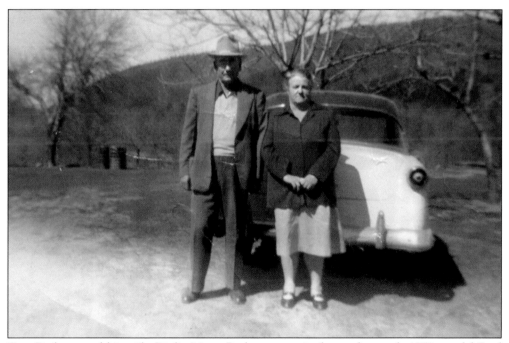

Tom Barbour and his wife, Birdie Myers Barbour, pose in front of an early 1950s model Ford automobile. More interesting than the car is what is seen in the background. Beyond the tree to the left is the gap at Smith Mountain where the dam would be built in less than 10 years. This photograph was taken at their home. (Courtesy of Diane Barbour.)

In addition to selling land to AEP for the construction of Smith Mountain Dam, the Barbour family also was involved with the project in other ways. Shown at left and below is Morris "Whitey" Barbour, who began working for AEP in 1954. His initial assignment was to collect water gauge measurements at the family farm along the Roanoke River. After construction began on Smith Mountain Dam, Barbour worked there until 1963, when he transferred to the Leesville Dam. In 1979, Barbour transferred back to Smith Mountain Dam where he remained until retiring in 1994. Whitey was the son of Tom Barbour. (Both, courtesy of Diane Barbour.)

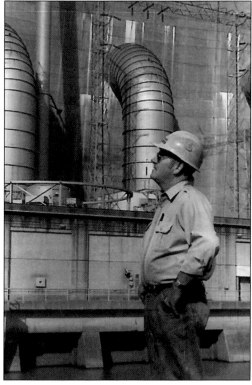

Two

CONSTRUCTION AT
SMITH MOUNTAIN

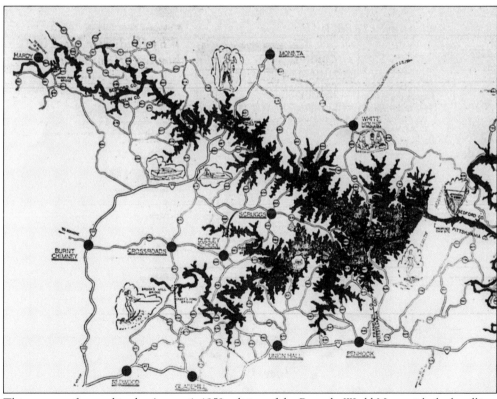

This map was featured in the August 1, 1959, edition of the *Roanoke World-News* with the headline, "Huge Lake Would Result from APCO Dam." The dark areas of the map represented the projected shoreline of the "mammoth new lake" and clearly showed the impact the lake would have on existing roads and property. The article accurately predicted the lake would have 500 miles of shoreline and cover approximately 25,000 acres of land. (Courtesy of the *Roanoke Times*.)

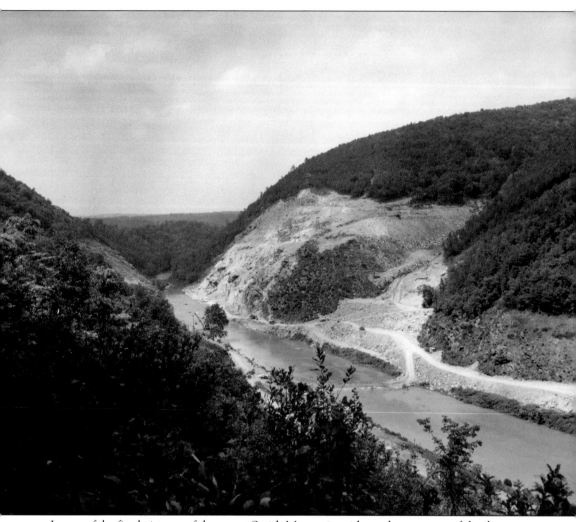

In one of the final pictures of the gap at Smith Mountain without the presence of the dam, access roads can be seen snaking around the sides of the mountain to the right and even across the Roanoke River. A crane sits at the ready on the left bank while dump trucks on the right bank appear primed to haul dirt away from the area. The trees and other foliage seen beyond the gap would eventually be cleared or covered by the rising waters of Smith Mountain Lake. This photograph was taken from the south side of the project on September 8, 1960, from a proposed overlook site. The primitive nature of the area is plainly evident in this image. (Courtesy of AEP.)

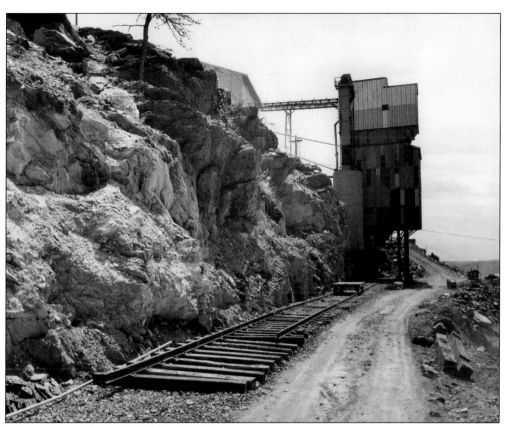

The main ingredient for building Smith Mountain Dam was concrete—and lots of it. A staggering total of 175,000 cubic yards of concrete was required for the construction project. To meet this challenge, a mixing plant (above) was built on-site above the ravine at about where the visitors' center is now located. On April 6, 1961, the *Franklin News-Post* reported that the Norfolk & Western Railroad had begun sending specially built 85-ton hopper cars filled with concrete sand from Petersburg, Virginia, for use at the Smith Mountain site. A cableway was built over the ravine and used to deliver building materials where they were needed, as they were needed. In the photograph at right, a load of concrete is about to be delivered via the cableway to the north thrust block. (Both, courtesy of AEP.)

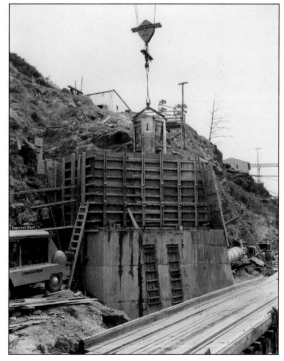

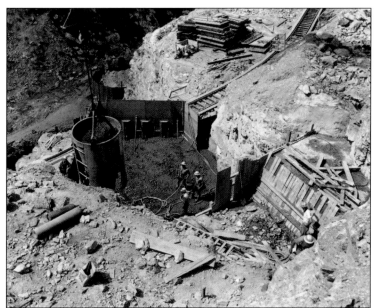

This photograph, taken on September 13, 1961, shows a bucket of concrete being delivered to the north thrust block via the cableway. Such ingenuity was required due to the nature of the massive undertaking and rural location of the construction project. The wilderness setting is well depicted in this image; the workers are dwarfed by their rock surroundings. (Courtesy of AEP.)

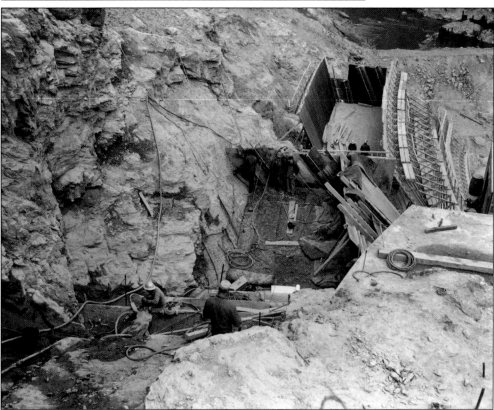

Workers are seen going about their individual tasks at the Smith Mountain construction site. To avoid injury and even death, workers had to be aware of not only what was going on in their own area, but also in areas above and behind them. This view is looking northwest into Blocks 1 and 2. (Courtesy of AEP.)

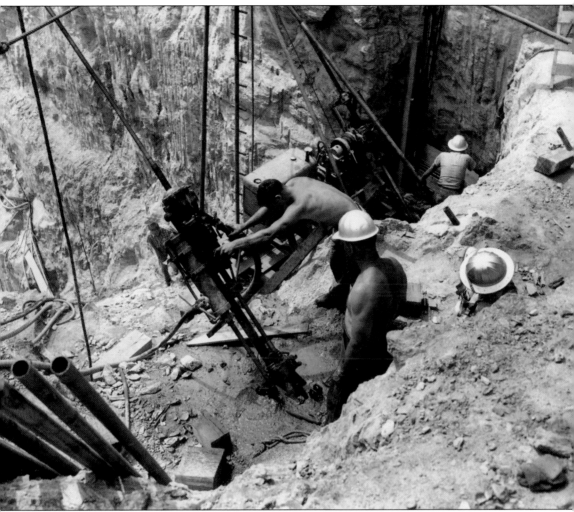

To help maintain the stability of the dam in the gap, blocks of concrete had to be buttressed and secured into the granite walls of the mountain. In this photograph from May 1961, workers can be seen drilling an ax plug in the north thrust block at Smith Mountain. When construction started at the dam site, there was a concern for the workers' safety—not only because of the normal hazards of the work, but also because of the natural dangers. Snakes were common in the area, and each worker was given a snakebite kit when construction first started at the dam. Fortunately, no one was ever bitten by a snake during the entire construction project. Heat during the summer months was another natural force the dam builders had to combat. Even in May, some of these fellows have become too warm to keep their shirts on, as the sun's heat must have been intensified by all the rock. (Courtesy of AEP.)

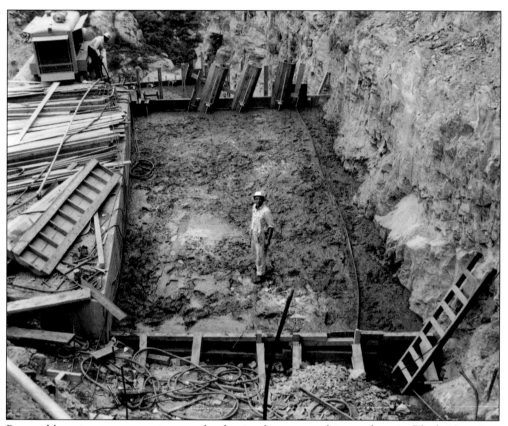

Pictured here is concrete setting up after having been poured into a form in Block 10 against the rock walls of the gap. What appears to be steel rebar can be seen protruding up through the concrete, especially above the worker facing the camera. Rebar (reinforced bar) is used to strengthen and hold concrete in place. (Courtesy of AEP.)

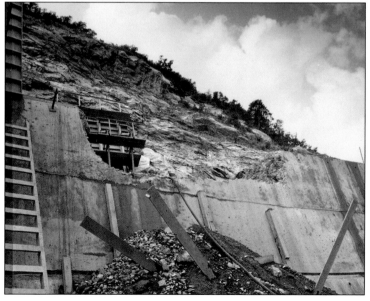

Not everything always goes as planned, as this photograph from September 6, 1961, proves. A section of concrete in a side block had to be cut out after it was determined that the concrete had been mixed with an over batch of retardant, which is a chemical means of "curing" the concrete. Such attention to detail was imperative to ensure the quality of the dam. (Courtesy of AEP.)

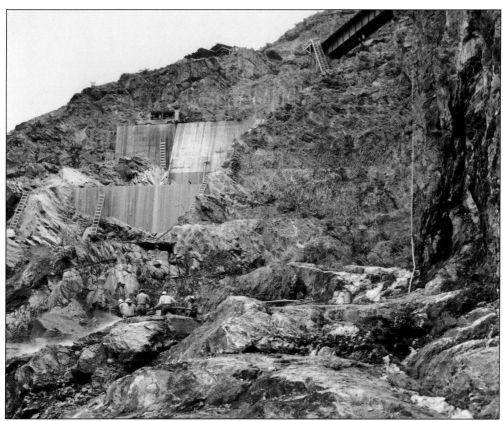

Concrete blocks set into the sides of the gap of Smith Mountain show the beginning of the transformation that took place as a result of the efforts of an army of workers. Taken in September 1961, this photograph provides a northwest view of the completed north fault remedial concrete and north spillway excavation. (Courtesy of AEP.)

Heavy construction equipment is caught in action on September 13, 1961. In order to be able to build forms and set concrete on the floor of the gap, something had to be done with the Roanoke River. In this photograph, a dike is being built for the first stage of diverting the river. (Courtesy of AEP.)

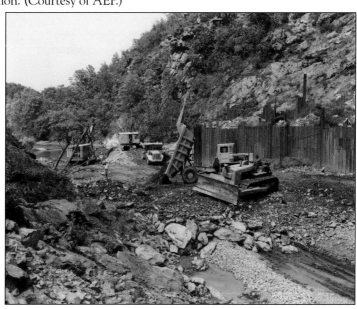

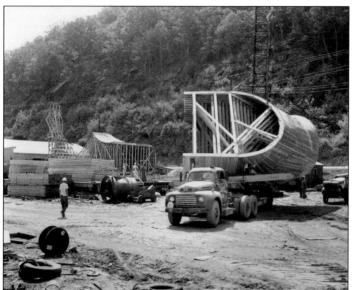

A Sollitt Construction truck waits to be unloaded at the Smith Mountain site on September 13, 1961. The truck is loaded with draft tube forms for Unit 3 and other draft tube forms can be seen in the background to the left. Although Unit 3 was not installed until after the other units, its draft tube and penstock were installed in preparation for the turbine's eventual placement. (Courtesy of AEP.)

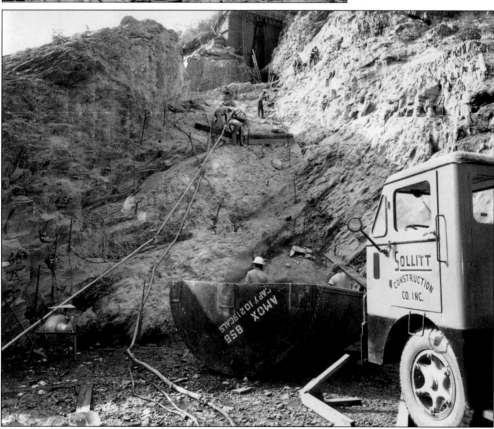

Another instance of Sollitt Construction's involvement with the Smith Mountain Project is pictured here. The George Sollitt Construction Company is still based in Chicago, Illinois. The company was incorporated in 1935, and other projects they have been involved with include Notre Dame Stadium and the Art Institute of Chicago. (Courtesy of AEP.)

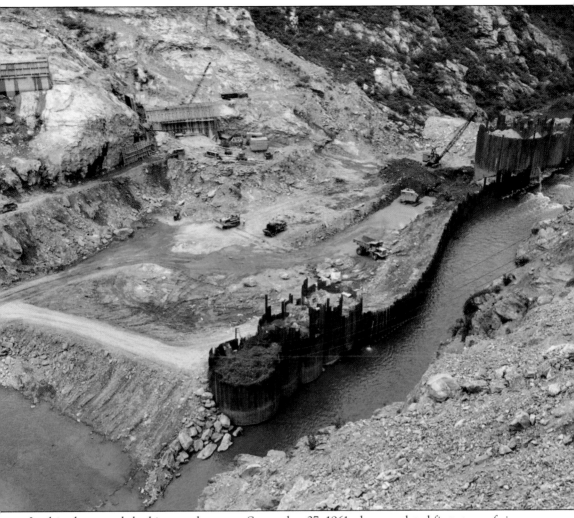

In this photograph looking southwest on September 27, 1961, the completed first stage of river diversion can be seen as well as a general view of the bottom of the gorge. With the Roanoke River diverted to the north bank, workers could begin construction on the base of the dam. Pumps can be seen removing water from the work area while dirt is being excavated from the site. Seen in the upper left side of the photograph are sections of the dam's walls abutted into the side of the mountain. Most of the area seen in this image is now well under water at Smith Mountain Dam. The complexity and enormity of the Smith Mountain Project would probably make such an undertaking cost-prohibitive in today's economy. (Courtesy of AEP.)

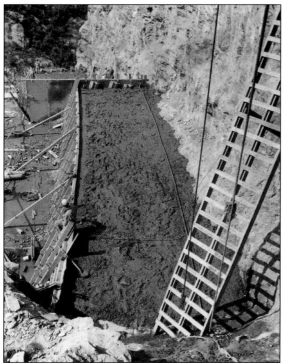

A worker seems to be getting a break while seated beside a massive amount of poured concrete in Block 10 on the south bank. Although the dam was constructed of concrete and steel, one of man's oldest building materials, wood, was used to create everything from forms to ladders at Smith Mountain. (Courtesy of AEP.)

This view shows workers conducting drilling operations for consolidation grouting on October 25, 1961. Consolidation grouting involves injecting grout to strengthen a layer of foundation and make the foundation less permeable. Cranes can also be seen on the floor of the work site while the diverted river is visible in the upper right-hand corner of the photograph. (Courtesy of AEP.)

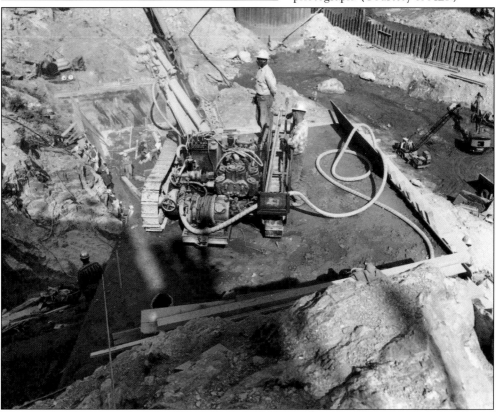

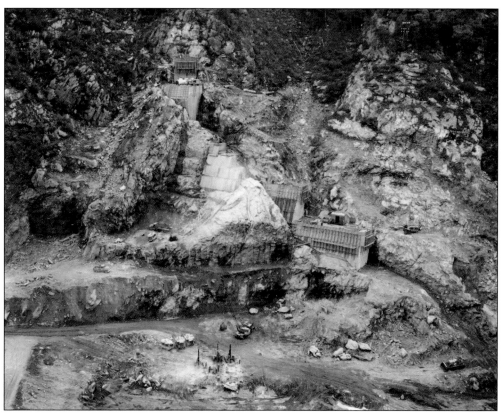

Another photograph, taken on October 25, 1961, provides an overall look at the progress of work on the south bank. Ladders are scattered across the landscape, providing access for workers to different levels of the job site. Bulldozers and other heavy equipment look like toys in comparison to the enormous rocks and cement blocks. (Courtesy of AEP.)

Meanwhile, across the river on the north bank, workers have not been idle. Seen here are the anchoring blocks set into the granite of the mountain. Crews have already blasted the rock, and the beginning of the curvature of the dam is apparent. The diverted Roanoke River is at the bottom of the photograph. (Courtesy of AEP.)

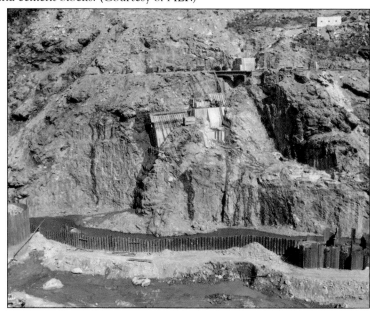

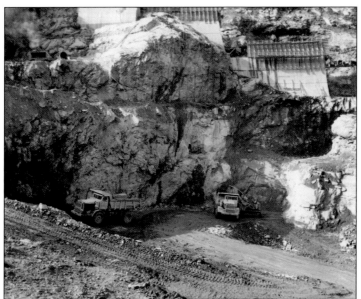

Huge dump trucks are dwarfed by the rock wall of the southwest side of the river. This photograph reveals the progress made as of November 22, 1961, in the powerhouse excavation. Explosives were used to blast out the rock and soil from the side of the mountain, and dump trucks transported the debris out of the work area. (Courtesy of AEP.)

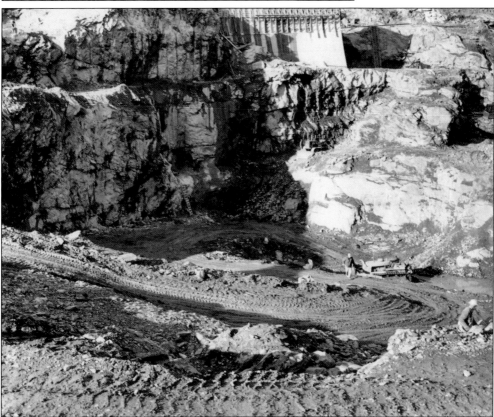

As is true with any permanent structure, a firm foundation is of vital importance. Shown here in a photograph taken on December 20, 1961, is another view of the excavation work that was being done for the location of the powerhouse at the dam. The powerhouse would eventually contain the turbines, which produce hydroelectric power. (Courtesy of AEP.)

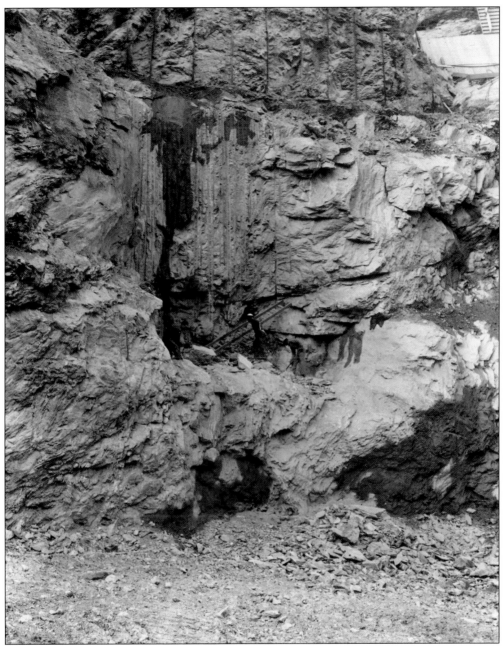

Men work on a ledge while excavating for a powerhouse sump in December 1961. The sump acts much in the same manner as a basement sump in a house. A sump is a low pit into which water seepage from the generator units and expansion joints collects before being pumped out. Such seepage is a normal occurrence at hydroelectric dams, and sumps continue to serve their purpose at the dam today. Cuts can also be seen in the rock above the men where earlier excavation work had been performed. During the peak period of construction, in the summer of 1962, there were between 750 and 850 contractors and 80 AEP employees working at the Smith Mountain Project. Supervision of the project was not only done on the ground, but also from a helicopter in the air. (Courtesy of AEP.)

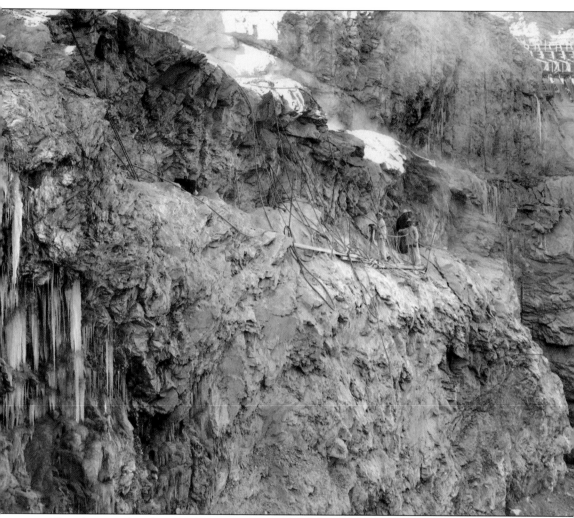

This photograph, taken on February 7, 1962, serves as a testament to the strength and hardiness of the American construction worker. In what must have been freezing conditions, these men are seen standing on planks on the ice-cold rocks of the southwest wall of the construction site. Ropes and cables seem to be the only support for their precarious perch. Confirming the frigid conditions are the giant icicles seen both to the left and right of the workers. The shadowing in the image indicates the men were not even getting the benefit of the winter sun. The caption that accompanied this photograph explains it was the scene of the excavation for a shore protection wall. (Courtesy of AEP.)

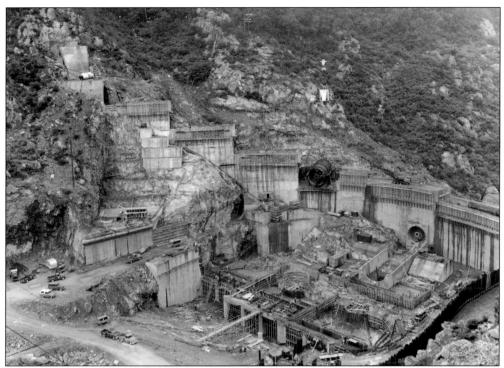

By July 1962, the definite outline of the dam at Smith Mountain could be seen on the south bank (above). In the foreground, work had progressed to the point that a draft tube could be seen taking shape, and construction of the powerhouse was well under way. On the north bank (below), work was also progressing as that side waited for the river to be diverted through the dam's south side. Completing one side at a time usually allowed work to be done without interference from the river. However, floods occurred once or twice a year throughout the construction period. (Both, courtesy of AEP.)

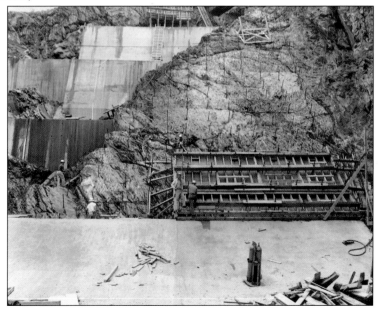

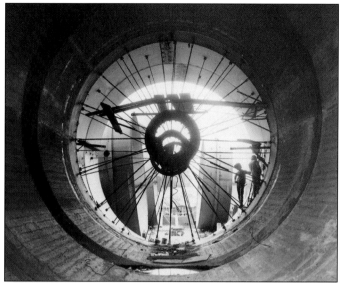

The inside of a diversion conduit is shown facing downstream on July 18, 1962. Workers provide a scale reference for the size of the enormous conduit, and the start of the steel rim can also be seen just outside the opening. Hundreds of craftsmen applied their skills at the Smith Mountain Project in a variety of jobs, including masonry, welding, and carpentry. (Courtesy of AEP.)

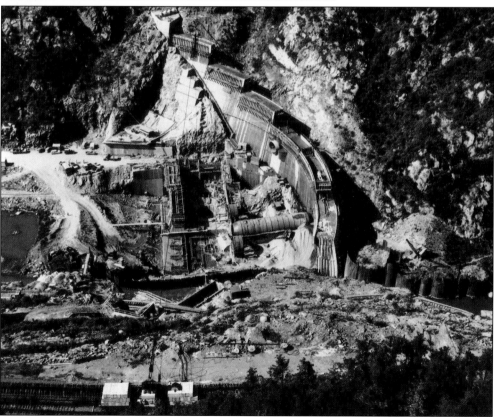

The caption on the back of this photograph from August 31, 1962, simply said "Progress." That seems to have been quite an understatement, as a tremendous amount of work appears to have been completed since the previous month. While the Roanoke River continued to be diverted on the north bank side, it would not be long before it would be channeled through the conduit in the dam. (Courtesy of AEP.)

Shown here are the huge penstock tubes that would carry water from Smith Mountain Lake to the dam's massive turbines. The unfinished, upright penstocks would serve turbine Units 2, 3, and 4. Note the size of the upright penstock in the foreground in relation to the worker standing on the side of it. This photograph was taken in November 1963. (Courtesy of AEP.)

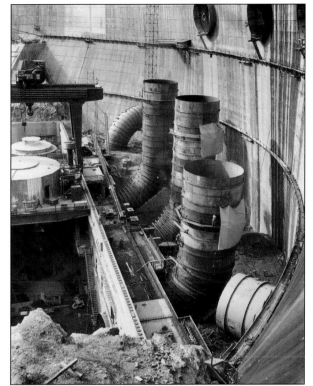

A recent view of Smith Mountain Dam is shown here to provide a look at how the penstock tubes looked after completion. Visible in the photograph are penstock tubes for Units 1, 2, 3, and 4. The penstock tube for Unit 5 is low and hidden below the hill in the right foreground. (Author's collection.)

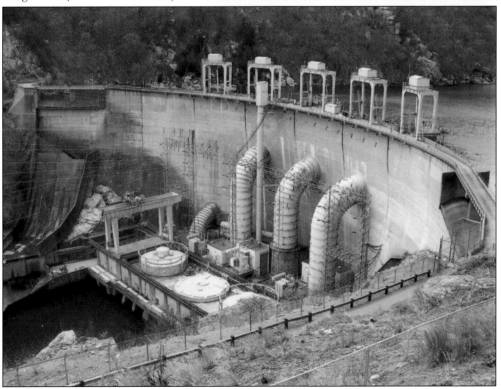

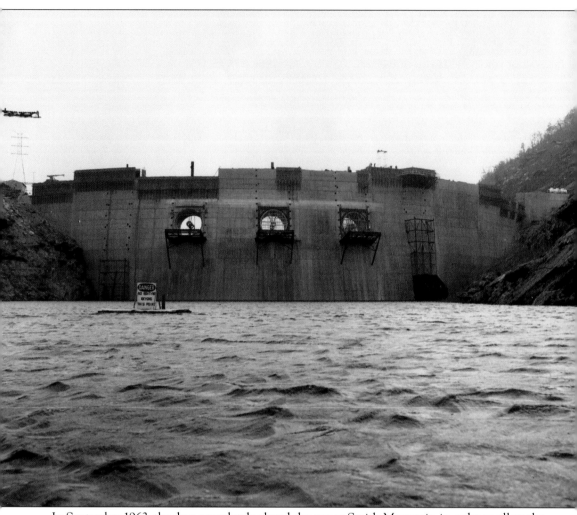

In September 1963, the dam completely closed the gap at Smith Mountain in order to allow the lake to begin to form. This photograph was taken facing downstream on December 18, 1963, and shows how much the water had risen just behind the dam. Behind the photographer, what had been mainly farmland and forests was becoming the floor of Smith Mountain Lake. The floating sign in front of the left side of the dam warned boaters not to come any closer to the dam. Construction work can be seen continuing on top of the dam, and none of the hoist houses used for lifting the gates to allow water into the penstock tubes had yet been erected. The penstock tubes also had yet to be connected to the dam. (Courtesy of AEP.)

Three

RISING WATER

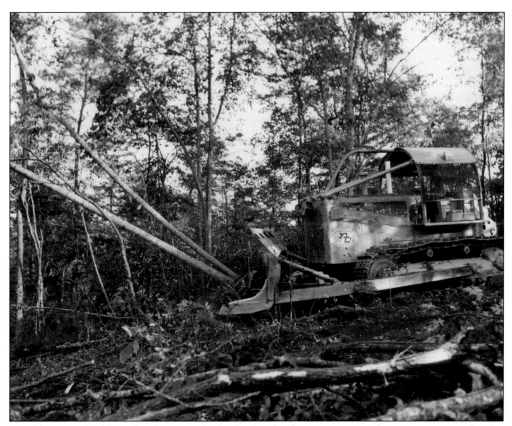

In addition to building the dams, work also had to be done to prepare the reservoir areas for the rising water. Crews cleared a large amount of land to reduce the amount of debris that would be in the water once Smith Mountain Lake filled. Shown here is a tractor being used by the Nello L. Teer Company to clear land in the reservoir area on October 11, 1961. (Courtesy of AEP.)

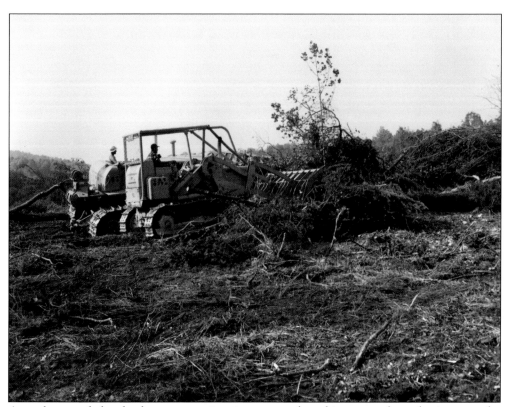

As work proceeded at the dam construction sites, men and machinery were busy clearing away the reservoir areas of timber and brush that might pose a hazard to the dams and future watercraft. Shown here on October 11, 1961, a "root rake" is used on a bulldozer to clear an area of the Smith Mountain Lake reservoir. Another dozer stacks trees and brush for burning. (Courtesy of AEP.)

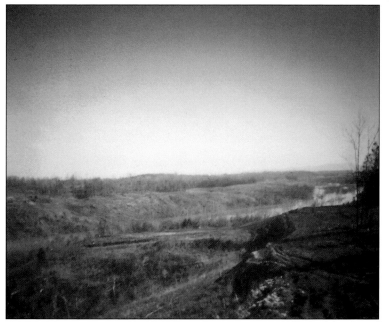

Taken in February 1964, this photograph allows a view of what the area near Hales Ford looked like before the lake filled in. The Roanoke River is visible and, although excavation has been done on the riverbanks, there is no other indication of the changes that would soon come to this area. (Courtesy of Carl W. Moyer.)

Access roads had been severed by the rising lake by the time this photograph was taken in February 1964. Felled trees are strewn around the landscape as others are slowly being swallowed by Smith Mountain Lake. The higher ground in the image would also eventually be overcome by the waters of the upper reservoir. (Courtesy of AEP.)

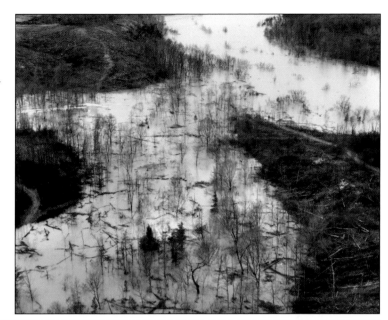

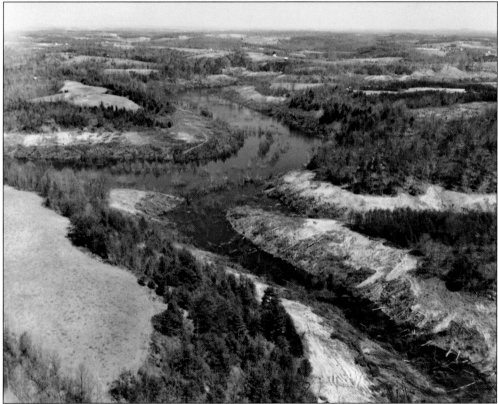

A common scene is shown here as the Roanoke River backed up and began to fill in the lake behind Smith Mountain Dam. Partially submerged trees and floating debris can be seen in this photograph taken of a cove somewhere above the Hales Ford area in April 1964. Trees above a certain height were cut down to allow future water traffic to pass unimpeded. (Courtesy of AEP.)

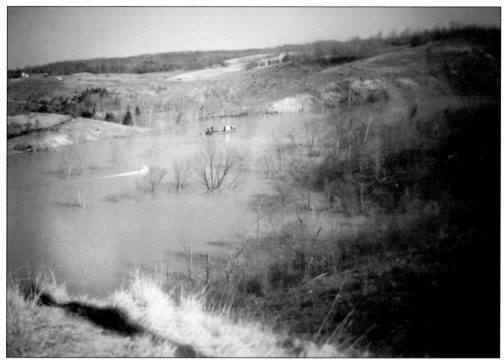

Another image from the Hales Ford area captures the rising water and disappearing trees. Partially submerged trees would have made boat navigation challenging. Judging by the small wake, the boat approaching the crane barge was traveling at a low speed through the aquatic forest. Within a few years, watercraft traffic would greatly increase in this area. (Courtesy of Carl W. Moyer.)

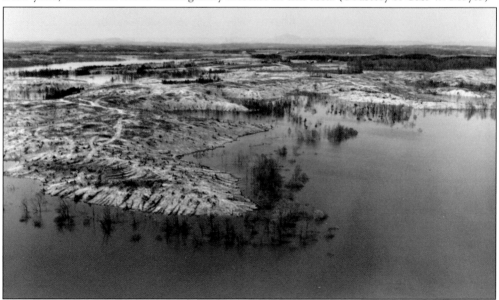

With farms and fields in the background and the rising lake in the foreground, this photograph from April 1964 provides an excellent view of the transition that occurred with the formation of Smith Mountain Lake. Also plainly visible is the land cleared in order to minimize the amount of debris in the water. (Courtesy of AEP.)

This photograph was also taken in April 1964, and the lake's progress in overtaking the boundary between land and water is significant. The trees and foliage that were left standing became ideal habitats for the various species of fish and other aquatic life in the lake. (Courtesy of AEP.)

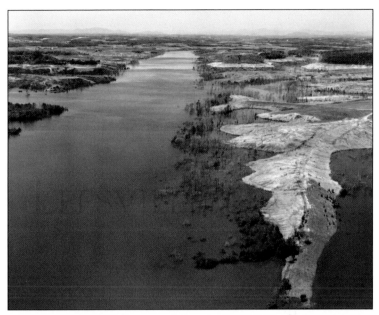

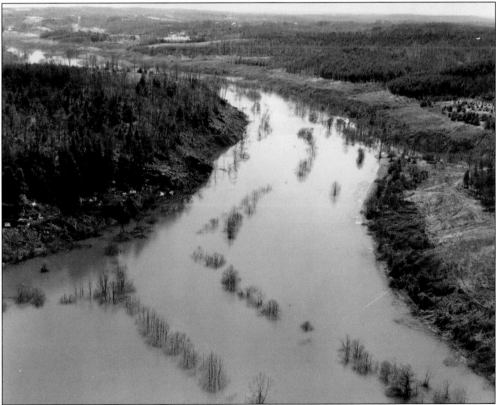

The caption that accompanied this photograph indicated it was of the reservoir above Hales Ford Bridge. This view shows the snaking shape of the river and, at the same time, gives a hint of how much the banks would be changing and growing farther apart. The murkiness of the water can also be seen. (Courtesy of AEP.)

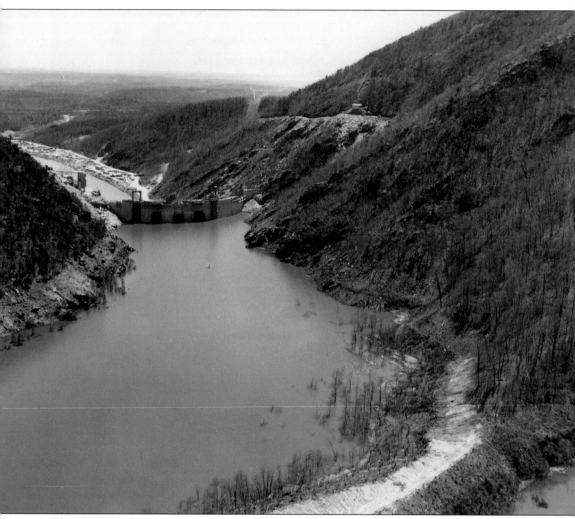

This is what Smith Mountain Dam looked like on April 1, 1964. The lake was still two years from being declared filled to capacity, and rocks on the shoreline that are now submerged can still be seen. Below the dam is the cement production facility on the left bank, and beyond the dam lies the home base of continued construction efforts on the right bank. Some of the buildings on the right bank are still used by AEP, but much of the lower right bank was converted to a recreational and picnic area. On the visible side of the dam are three of the massive screens that were designed to prevent trash and debris from entering the penstock tubes. Originally, these screens were fixed, but it was discovered the screens were being blown off when water was pumped back from Leesville Lake. The screens were then converted so that they can be raised when water is returned to Smith Mountain Lake. (Courtesy of AEP.)

Four

THE LEESVILLE DAM

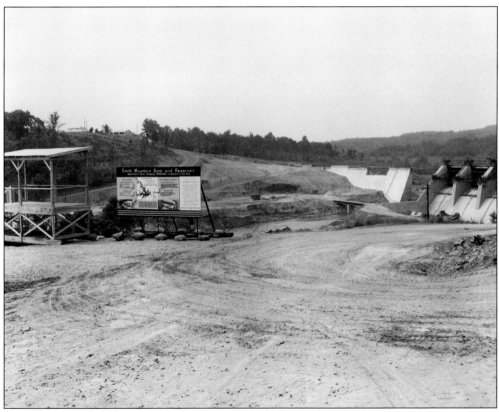

A sign at the Leesville Dam construction site proclaims the Smith Mountain Project to be "Appalachian Power Company's $50,000,000 Investment In This Area." To the left of the information sign is an elevated visitors' overlook where progress on the Leesville Dam could be observed. This photograph was taken on May 23, 1962. (Courtesy of AEP.)

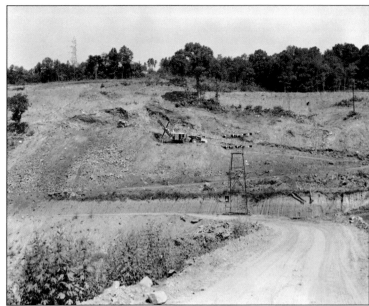

The Leesville Dam, although smaller than its sister dam at Smith Mountain, is an integral part of the pumped storage plan. It holds the water until the water is pumped uphill by the larger dam and back into Smith Mountain Lake. Shown here is a view of work on the north access road to the top of the Leesville Dam taken on September 13, 1961. (Courtesy of AEP.)

In addition to being smaller than the dam at Smith Mountain, the Leesville Dam is also a different type. The Leesville Dam is a concrete gravity dam, which holds back water using the weight of the dam, while the Smith Mountain Dam is classified as a concrete arch dam, which is designed to take the pressure of the water to compress and strengthened the structure. Shown in this photograph from September 1961 are wooden forms to be used in the construction of the Unit 2 draft tube at Leesville. (Courtesy of AEP.)

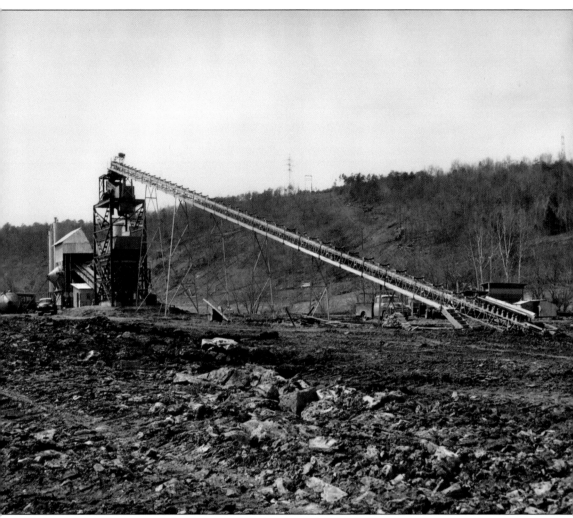

Since the rural location of the dams made it impractical to haul the massive amount of cement needed for their construction, the cement was made on-site. In this image from March 1961, the beginnings of the S.J. Groves' concrete batching plant at the Leesville Dam can be seen. Additional parts and equipment for the plant are also visible lying on the ground near the truck to the left in the photograph. At the top, electrical towers can be seen with power lines stretching down the hill and across the distant horizon. Chunks of soil churned up by bulldozer tracks litter the ground in the foreground. Even though Leesville was a smaller construction project than the dam at Smith Mountain, the job was still a challenge to the stamina of workers and supervisors alike. (Courtesy of AEP.)

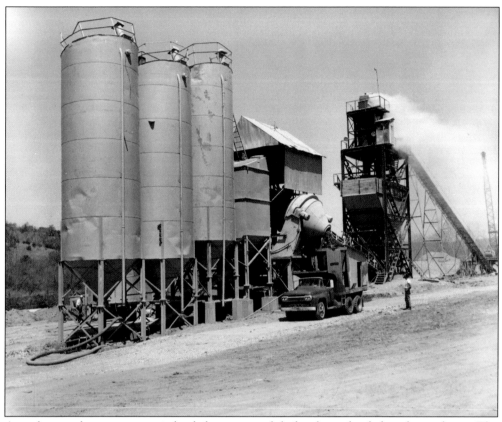

A worker watches as concrete is loaded onto a truck before being hauled to the work site. The special conditions created by the location and massive nature of the dam's construction required engineers and construction workers to frequently think outside the box, even before the phrase was coined. (Courtesy of AEP.)

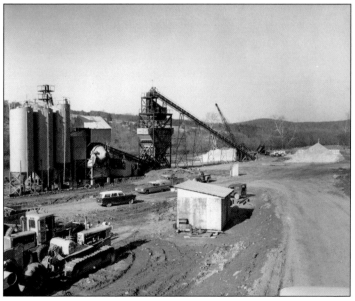

Heavy construction equipment and stockpiles of concrete sand can be seen in this photograph of the concrete batching plant. A sign on the side of the facility reminds workers to think of safety first. The number of fatalities during the Smith Mountain Project was remarkably low. Only two workers were killed—one was backed over by a truck, and the other fell into a penstock tube and drowned. (Courtesy of AEP.)

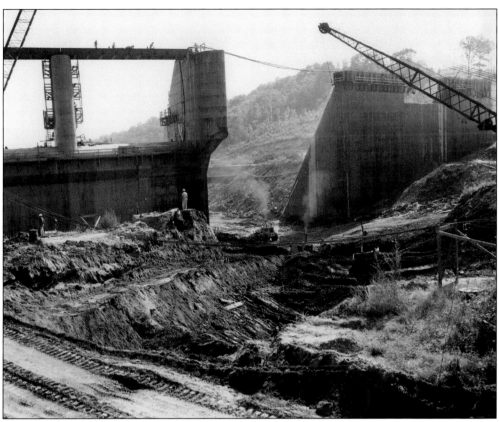

By the time this photograph was taken in September 1961, a great deal of progress had been made on the Leesville Dam. A diversion channel for the Roanoke River also had to be made at the Leesville site, and excavation for the second stage channel can be seen here. (Courtesy of AEP.)

An elevated view of the Leesville Dam gives a better perspective of the progress already made by September 1961. This angle is looking northwest and shows the spillway sections of the dam. Built at a height of 90 feet, Leesville is a much lower dam than Smith Mountain, which has a height of 235 feet. (Courtesy of AEP.)

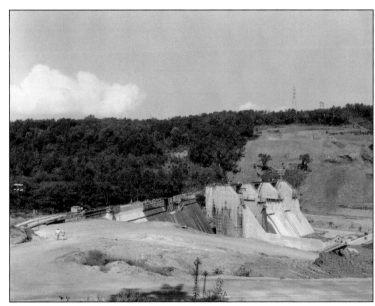

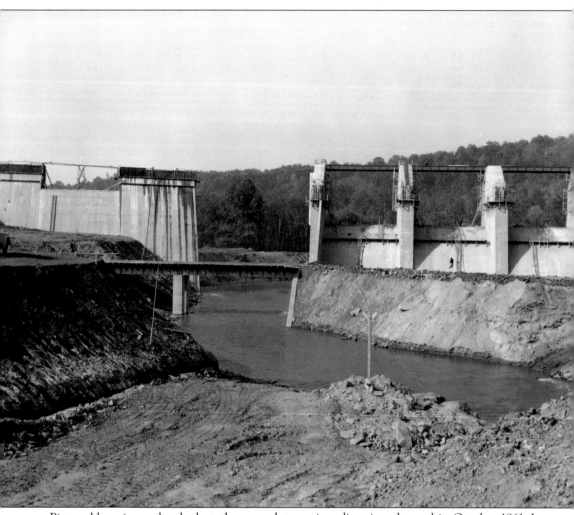

Pictured here is another look at the second stage river diversion channel in October 1961. In the foreground of the photograph is the temporary bridge built for contractors to use to cross the Roanoke River as necessary. In the background are portions of the completed spillway and right gravity sections of the dam. Forestland can be seen beyond the construction site and the image provides a glimpse of what the area looked like before construction began. It is amazing that AEP was able to determine with so much accuracy the boundaries of Smith Mountain Lake and Leesville Lake. The shores of the Leesville Reservoir are located primarily in Pittsylvania County but also include Campbell and Bedford Counties. The shoreline is 100 miles long, and the lake contains 94,960 acre-feet of water on average. (Courtesy of AEP.)

Construction is in full swing at the Leesville Dam in another photograph from October 1961. This view is looking southeast and shows the excavation for the intake for powerhouse Blocks 5 and 6. In the top left of the photograph is the S.J. Groves concrete batching plant. (Courtesy of AEP.)

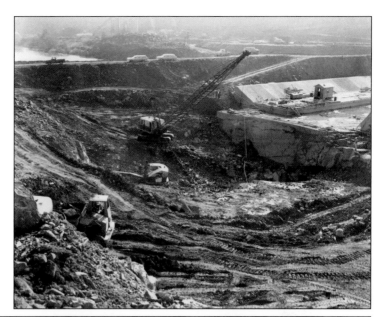

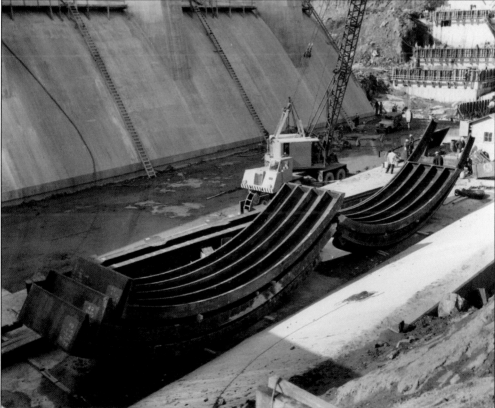

In November 1961, the face sections of the first Tainter gate were delivered to the Leesville Dam construction site. They are the curved objects in the foreground of the photograph. The Tainter gate, used to control water flow, was invented in the 19th century by American engineer Jeremiah Burnham Tainter. (Courtesy of AEP.)

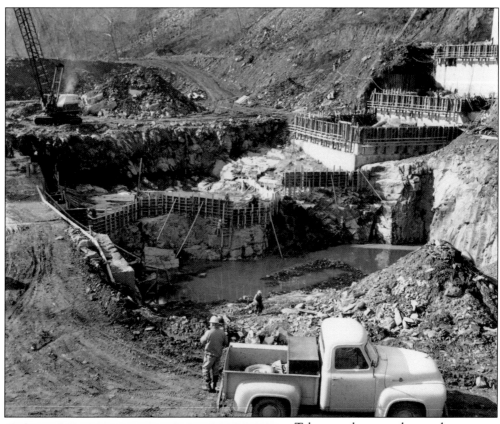

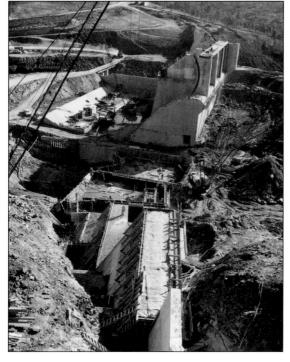

Taken on the same date as the previous photograph, this image shows a view to the west of the initial formwork on intake Blocks 5 and 6. The Leesville Dam is 980 feet in length while the Smith Mountain Dam is slightly shorter at 816 feet. (Courtesy of AEP.)

A wider view of the Leesville Dam construction site is seen in this photograph from December 1961. Looking south, the north abutment is in the foreground and the powerhouse sections of the dam can be seen. The Tainter gate sections are also visible lying in the spillway area. (Courtesy of AEP.)

The diversion of the Roanoke River at the Leesville site is plainly evident in this photograph, also taken in December 1961. This shot was taken facing the southeast and shows the spillway and the access road to the job site. A light stand can be seen near the building in the center of the image, which allowed for night work. (Courtesy of AEP.)

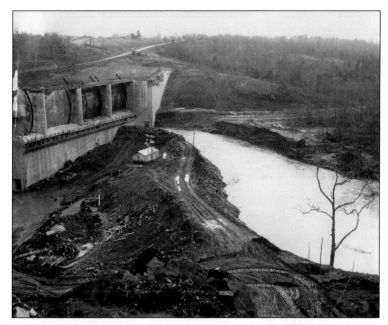

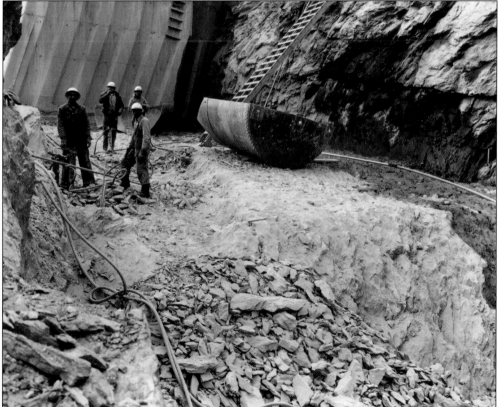

These workers appear to have already put in a day's work by the time this photograph was taken in December 1961. This view is looking south across Block 4 at Block 3 and shows rock being broken up below the grade in the fault zone of Block 4. (Courtesy of AEP.)

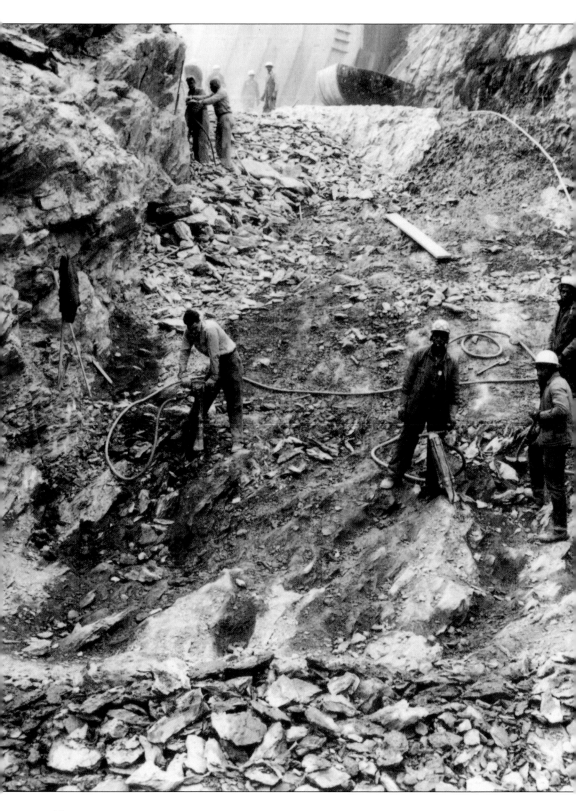

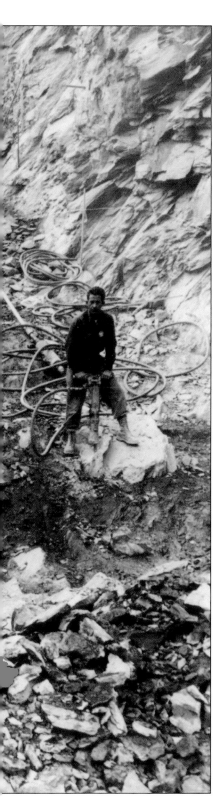

Workers at the Leesville Dam construction site pause momentarily to have their photograph taken in the excavation area in Block 5 on December 6, 1961. The three workers in the foreground are using pneumatic jackhammers to crush rock. The jackhammers were powered by compressed air delivered through hoses, and the sound of the jackhammers all going at once must have been deafening. However, none of the workers appear to have been wearing ear protection when the photograph was taken. Another great aspect of this image is the fact that whites and African Americans are seen working side by side during the midpoint of the civil rights movement in the South. (Courtesy of AEP.)

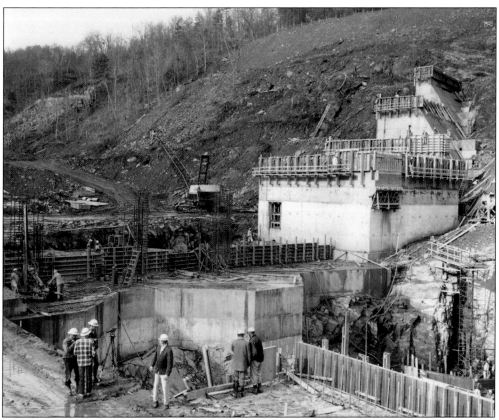

The men at the bottom of this photograph from December 1961 appear to be in deep discussion over some point regarding work in the powerhouse intake construction area. Meanwhile, other workers continue to labor on form building and cement placement. This is also a good view of the deep abutment on this end of the dam. (Courtesy of AEP.)

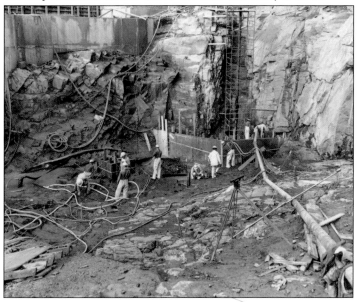

A maze of lines and hoses cover the ground as workers perform their various jobs in the powerhouse section of Block 5 in December 1961. Crews sometimes had to pump water out in order to pour concrete or gain access to specific areas, and hoses on the left appear to be aiding in that effort. (Courtesy of AEP.)

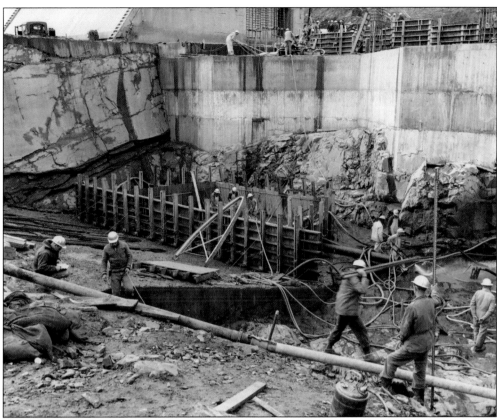

These men shown working in December 1961 were not only subject to the winter air but also frigid water. This photograph was taken facing southwest and shows the draft tube forms of Block 6. The goal of completing the Leesville Dam in conjunction with the dam at Smith Mountain must have given workers additional pride in the quality and importance of their jobs. (Courtesy of AEP.)

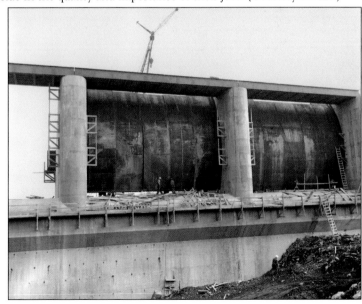

Looking east, this photograph shows the spillway Tainter gates partially installed. These gates designate the Leesville Dam as a controlled spillway dam. The gates can be opened in the event that the water level behind the dam becomes too high. During flood conditions, the US Army Corps of Engineers take control of the spillway. (Courtesy of AEP.)

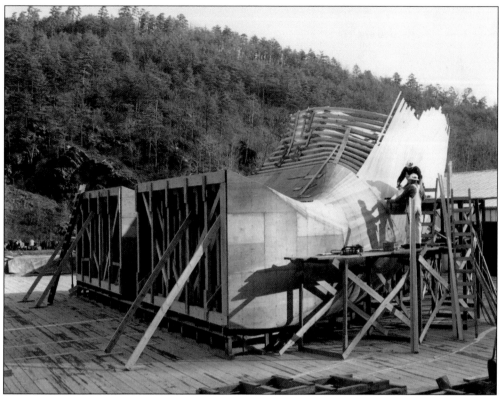

Men on scaffolding are dwarfed by a draft tube form at the Leesville construction site. Although much smaller than the draft tubes at Smith Mountain, the draft tubes at Leesville perform the same function. Draft tubes act as an exhaust conduit. After water leaves the turbine, the draft tubes are designed to keep the correct back pressure on the turbines. The Leesville Dam has two generating units, and this draft tube was used for Unit 1. (Courtesy of AEP.)

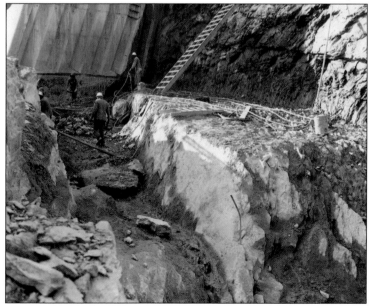

To get a sense of the pace of progress in building the Leesville Dam, compare this photograph to the bottom image on page 45. The photographs were taken at the same location looking south into Block 4, but this photograph was taken 14 days later on December 20, 1961. (Courtesy of AEP.)

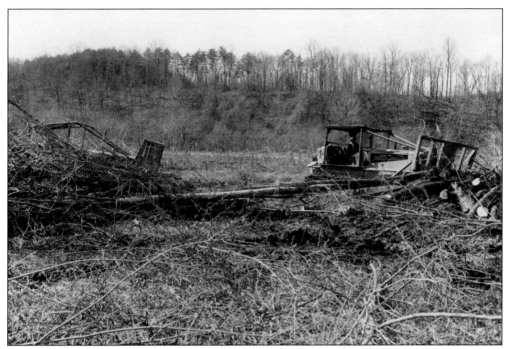

An area between Smith Mountain Dam and Leesville Dam was also cleared in preparation for the Leesville Lake/Reservoir. Trees were felled and bulldozers (above) were used to clear the debris. Additional clearing (below) allowed for the expansion of the river to form the shoreline of Leesville Lake. The normal maximum operating level of the lake is 613 feet above sea level, and the lake covers 3,270 acres. Since the completion of the Smith Mountain Project, water levels at Leesville Lake can fluctuate as much as 13 feet when water is released from or drawn back to Smith Mountain Lake. The photographs shown were taken in March 1962. (Both, courtesy of AEP.)

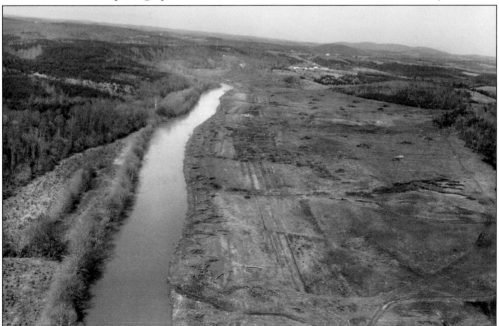

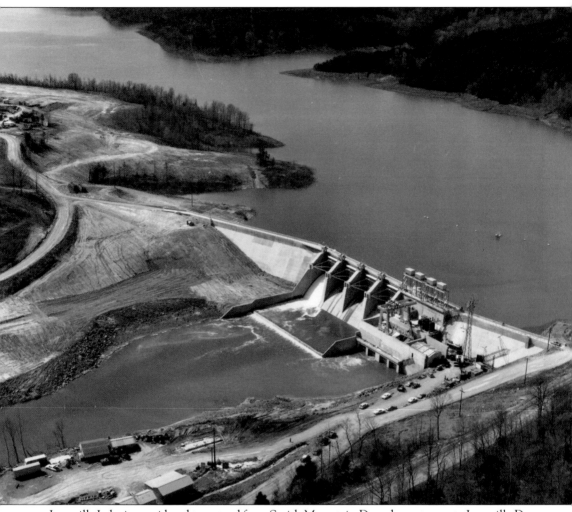

Leesville Lake is considered to extend from Smith Mountain Dam downstream to Leesville Dam. Taken on April 5, 1963, this photograph provides a clear view of the Leesville Dam and Lake. The Roanoke River is seen continuing on its way after passing through the dam. In August 2003, the Leesville Lake Association was formed to monitor and protect the water quality of the lake as well as to assist with the cleanup of the water and shore. The group also promotes safe recreational use of the lake and economic development in the lake area. The Leesville Lake Association hosts an annual Beautification Day, during which members and guests collect and remove debris from the water and shoreline. During the 2014 effort, almost 30 tons of debris were removed. The association had 275 members as of April 30, 2014. (Courtesy of AEP.)

Pictured here is Leesville Dam as it appeared on January 12, 1966. By this time, the lake at Smith Mountain was almost filled to capacity, and the dams were working in concert not only to produce hydroelectric power, but also to create one of the most popular recreational sites in Virginia. (Courtesy of AEP.)

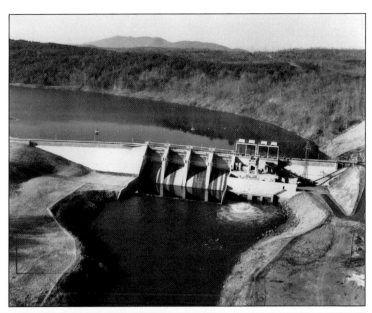

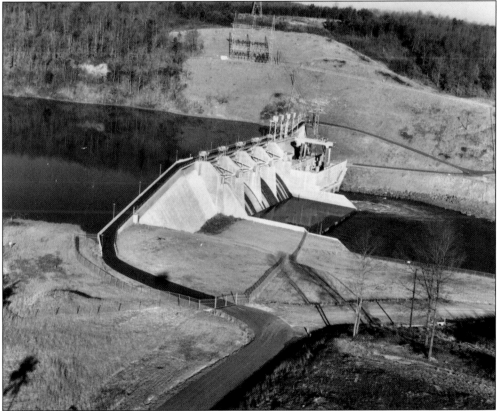

Another view of Leesville Dam was taken in January 1966. This photograph captures the dam working at capacity as well as the now paved access road leading to the top of the structure. An electrical substation can be seen on the far hill above the dam. There are two generating units at Leesville Dam, each with a production capacity of two megawatts. (Courtesy of AEP.)

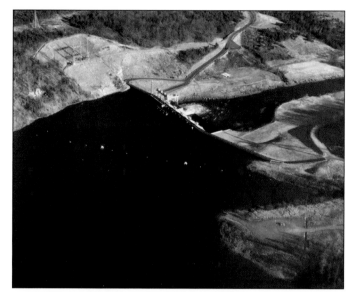

An aerial photograph of the back of the Leesville Dam reveals just how much the water had backed up into Leesville Lake by January 1966. Much of the same terrain can be seen in this photograph as was visible in the previous image, including the access road and substation. (Courtesy of AEP.)

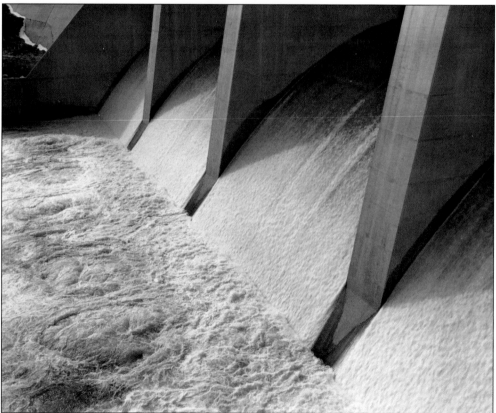

Water flows through the Leesville Dam in this photograph from February 6, 1963. The water released from Leesville Dam is approximately the same volume that naturally enters the Smith Mountain Project from the Roanoke River and its tributaries, the Blackwater and Pigg Rivers. After leaving the Leesville Dam, an 81-mile section of the Roanoke River becomes the Staunton River. (Courtesy of AEP.)

Five

FILLED TO CAPACITY

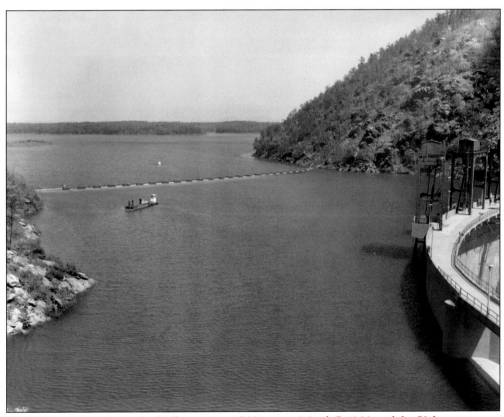

Smith Mountain Lake reached full capacity at 5:03 a.m. on March 7, 1966, and the 50th anniversary of the occasion will occur in 2016. This photograph shows the lake at full capacity on May 4, 1966. The line in the water is the trash boom, which serves to keep debris and trash from floating to the dam from the lake. (Courtesy of AEP.)

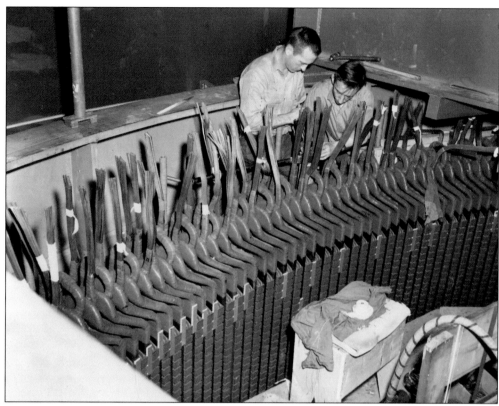

While Smith Mountain Lake filled, work continued at the dam. The machinery that was needed to make electricity from the power of the lake's water was too big to ship to the site intact. As a result, it had to be shipped in parts and assembled once it reached its destination. In the two photographs on this page, work is being done to install the stator coils in Unit 1 on December 18, 1963. The stator coils are the stationary part of the generator that surrounds the rotating part to make electricity as it is turned by the turbine. (Both, courtesy of AEP.)

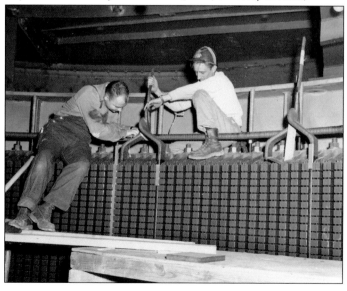

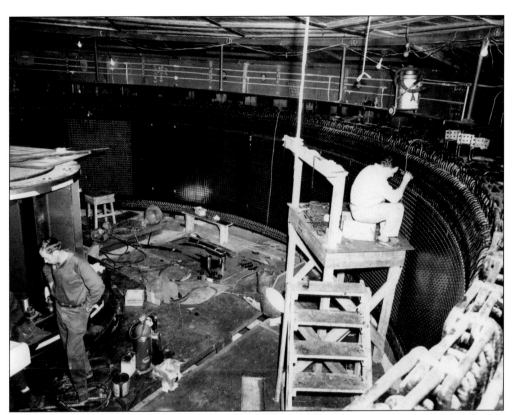

The impressive size and complexity of the mechanics of harnessing hydroelectric power at Smith Mountain Dam can be seen in this photograph from May 1, 1965. Here, AEP employees work on the stator in Unit 4. The gentleman on the raised platform seems to be in deep concentration as he examines the stator windings. (Courtesy of AEP.)

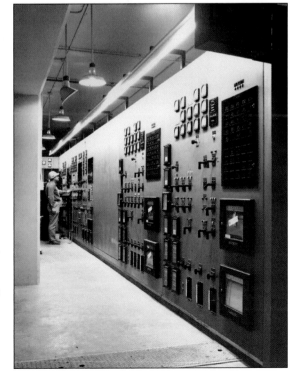

A worker monitors the main control panel at Smith Mountain Dam in 1965. The control panel allows for local monitoring of the operation as well as any adjustments requested by officials at AEP. The dam's operation has always been primarily remotely controlled, and this is now done by AEP in Columbus, Ohio. Adjustments at the dam are made on the basis of power needs on the grid. (Courtesy of AEP.)

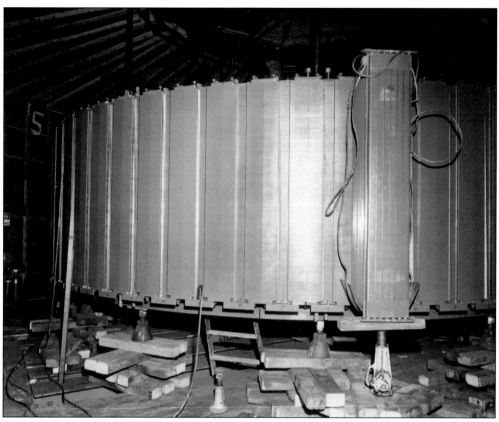

Shown here is the rotor in Unit 5 at Smith Mountain Lake on June 23, 1965. The rotor is being temporarily supported by blocks of wood during field pole installations. Once spinning, these field poles become huge electromagnets, setting up lines of force and inducing the electrons in the stationary stator windings to move and generate electricity. (Courtesy of AEP.)

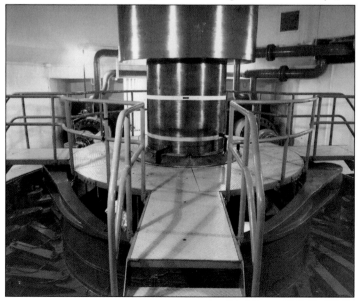

This is the turbine pit of Unit 4 at Smith Mountain Dam as it looked on September 21, 1965. Visible in the photograph is the turbine shaft. Also visible in the background are the two servomotors that turn the operating ring, which is wrapped around the turbine shaft. Connected to the operating ring are the linkage arms connected to the wicket gates, which control water flow. (Courtesy of AEP.)

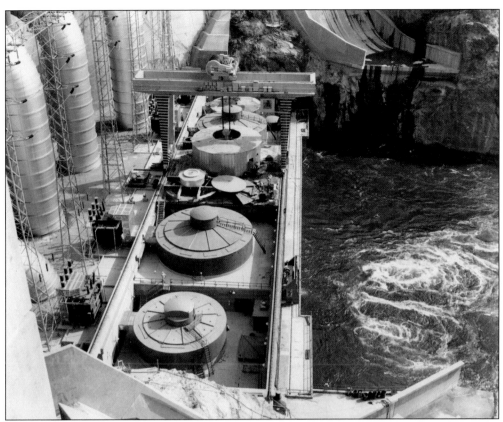

Shown in both photographs are the original four turbine generator units in the powerhouse at Smith Mountain Dam in 1965. The four units cost a total of $66 million, and a fifth unit was added at a cost of $37 million in 1979. A mobile crane called a "Gantry" is also seen in the top of both photographs. The Gantry crane is able to lift as much as 420 tons and is used to install and service the generating machinery. Also visible in both images are the massive penstock tubes that supply water to the turbines. (Both, courtesy of AEP.)

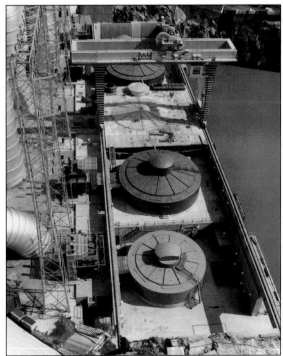

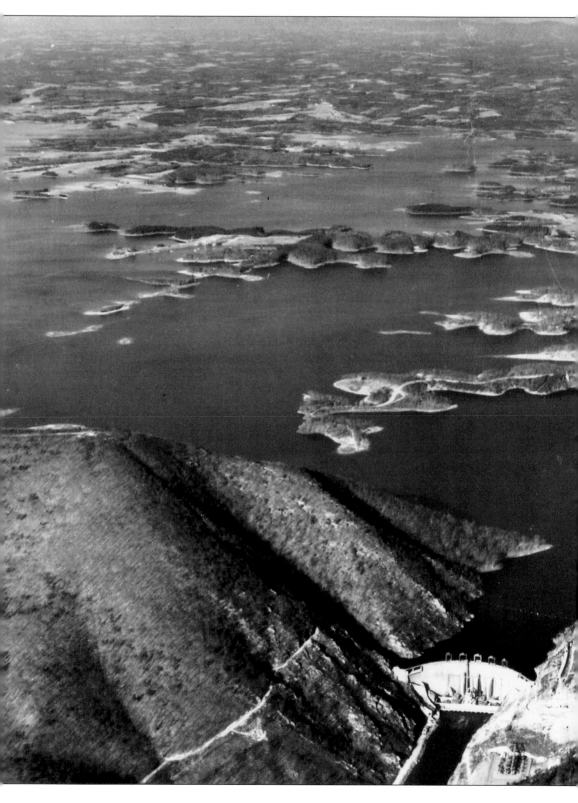

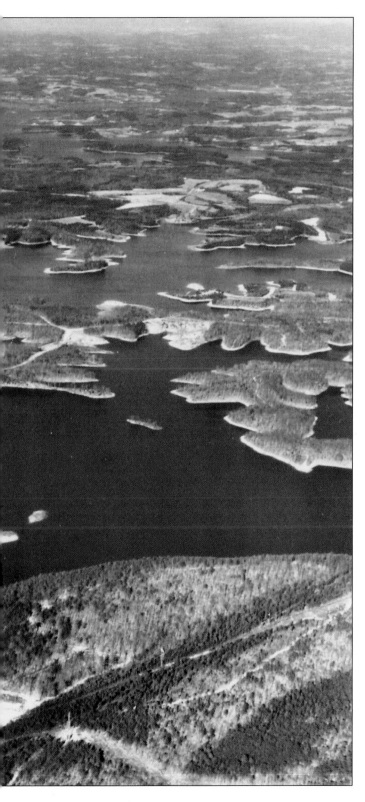

This panoramic view of Smith Mountain Dam and the upper reservoir was taken on April 26, 1965. The dam is dwarfed by the enormousness of the mountains and the lake itself. The man who served as the APCO resident engineer for the Smith Mountain Project, Earle T. Snodgrass, first visited the gap at Smith Mountain in the fall of 1959. Snodgrass had already been an engineer with the power company for 29 years when he was given the assignment at Smith Mountain, but he had never built a dam. Snodgrass's engineering knowledge came from correspondence courses he took early in his career, and he gained experience while working on other AEP projects. (Courtesy of AEP.)

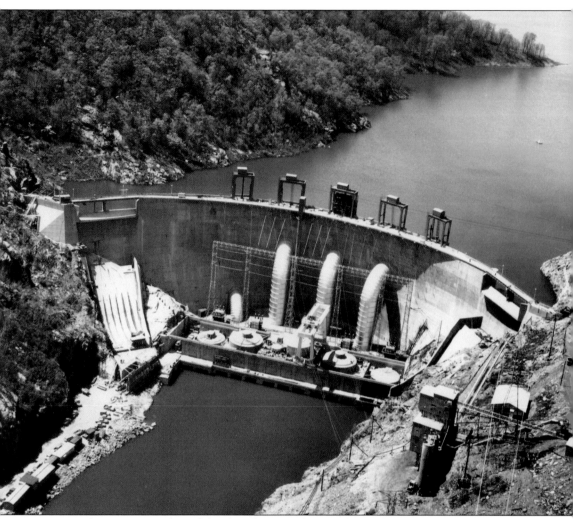

In another impressive shot of the dam from April 1965, the result of the labor and ingenuity of hundreds of AEP employees and contractors is displayed. The concrete mixing plant can be seen in the lower right hand corner of the photograph, and fixed spillways are visible on each end of the dam. Today, the Smith Mountain Lake Visitors' Center sits about where the concrete mixing plant was located. To the right of the visitors' center, an unpaved access road leads to the top of the dam. When this photograph was taken, the dam only had four turbine units, and the fifth unit was added in 1979. Three of the turbine units are reversed and used to draw water back from Leesville Lake when demand for power is low. (Courtesy of AEP.)

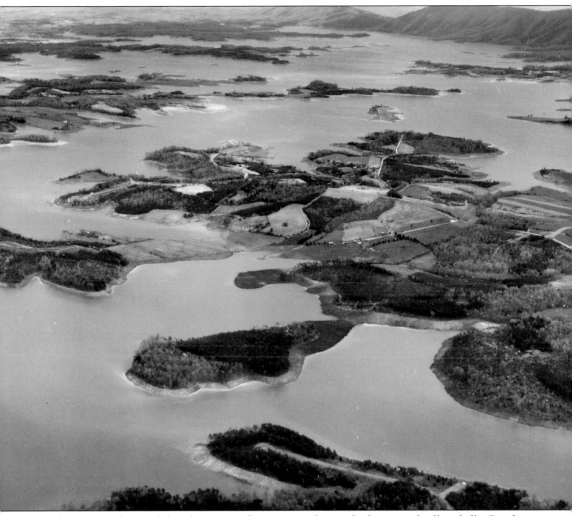

This photograph shows a lake where once there were only woods, farms, and rolling hills. Smith Mountain Lake had not yet reached capacity when this image was taken, and the shoreline continued to recede with the rising water. This view from April 1965 is looking toward Smith Mountain. Visitors to the area today often remark on the beauty of a lake framed by mountains. In an interview with the *Roanoke World-News* in the mid-1960s, Earle T. Snodgrass recalled visiting the area for the first time. Snodgrass remembered that the area was inhabited mostly by "deer, bear, bobcats, and snakes" at the time. He also recalled that an ill-tempered long-horned goat resided on Smith Mountain. Wildlife continues to thrive in the area, and visitors to the lake can usually count on seeing various species of birds in addition to deer, squirrels, and other woodland creatures. (Courtesy of AEP.)

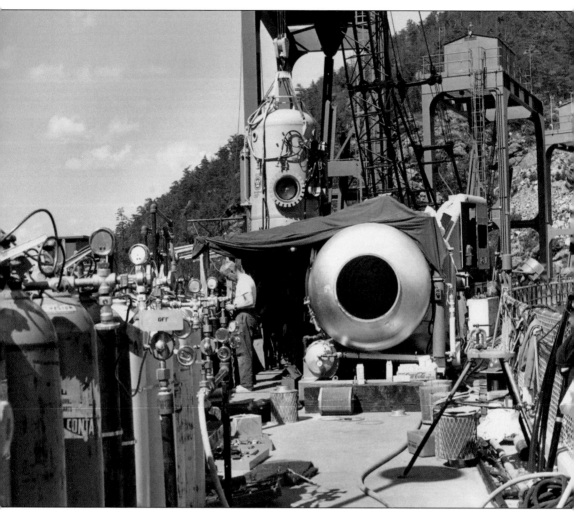

A submerged decompression chamber (SDC) is shown hanging from a hoist on top of Smith Mountain Dam on September 21, 1965. The apparatus under the makeshift tent is a deck decompression chamber (DDC). The DDC was used to acclimate divers to underwater pressures prior to using the SDC to reach work areas far below the water's surface. The SDC and DDC were brought to the dam to enable divers to reach underwater trash screens 200 feet under water at the dam. The screens, which were designed to keep debris from entering as water flowed into the penstocks, had become clogged with trees and other rubbish from the lake. Known as saturation diving, due to divers becoming saturated with the pressure of the water depth at which they worked, the system allowed divers to remain at deeper depths for longer periods of time than previous methods used. (Courtesy of AEP.)

In these two photographs, also from September 21, 1965, the SDC is being lowered into the water. Two divers made the trip down after decompressing to the correct depth pressure in the DDC. This method, which was developed specifically because of the challenge at Smith Mountain Lake, allowed dive teams to trade out and work eight-hour shifts under water after exiting the SDC. The job of clearing the trash screens was projected to take two years, but the new diving system allowed it to be finished on December 24, 1965. Saturation diving and the required equipment were developed by Al Krasberg, who was employed by Westinghouse at the time. Krasberg is known as "the Father of Saturation Diving." (Both, courtesy of AEP.)

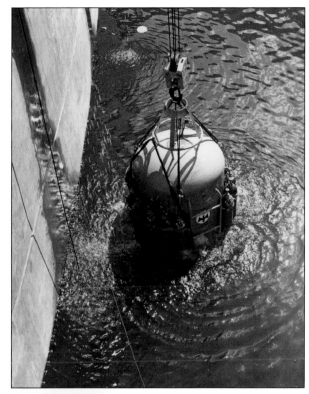

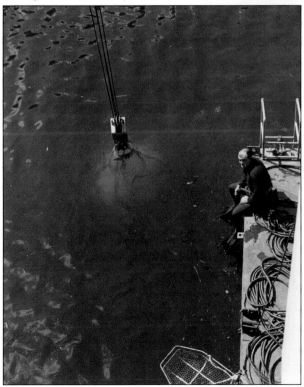

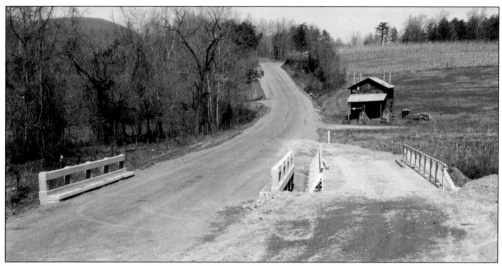

Shown here is a temporary bridge (right) over Cedar Creek, which allowed regular traffic to reach the access road to the dam. The sturdier bridge (left) probably had a supportive covering installed to protect it when used by heavy equipment. In the background is an old tobacco barn, which was used for flue-curing tobacco leaves after they had been picked. The barn still stands today. (Courtesy of AEP.)

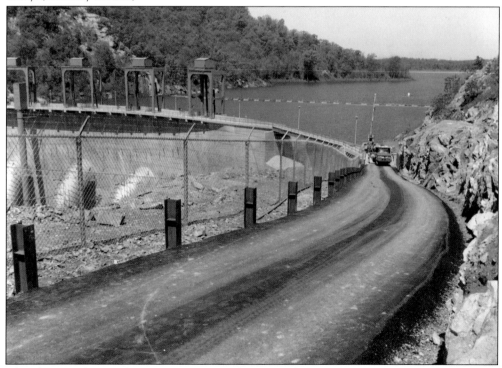

This photograph was taken on May 4, 1966, almost two full months after Smith Mountain Lake had reached full-pond stage for the first time. At the end of the paved access road in the foreground, workers can be seen on the edge of the top of the dam. Atop the center of the dam can be seen four of the five hoist houses, which contain machinery that lift large underwater gates to allow water into the penstocks. (Courtesy of AEP.)

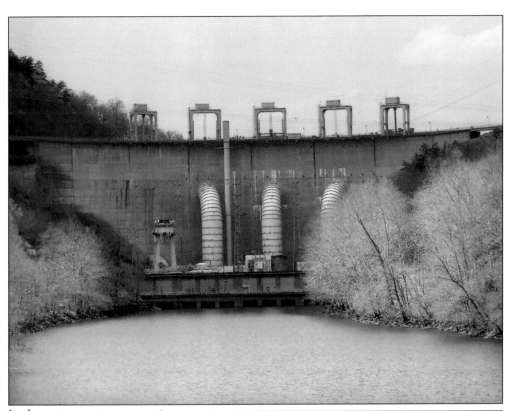

In these two contemporary views of Smith Mountain Dam, not much change is noticeable. The dam has almost become part of the mountain, having kept the gap closed for the past 51 years. Many residents of the area have never known the dam not to be there, and it continues to serve as an important part of the AEP network. The pole-like structure seen near the center of the above photograph is as high as a 17-story building and contains an eight-passenger elevator. The hoist houses are plainly seen on top of the dam in the photograph at right that was taken from just above the visitors' center overlook shelter. (Both, author's collection.)

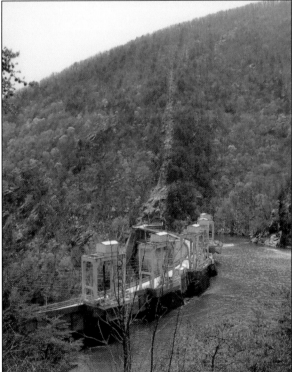

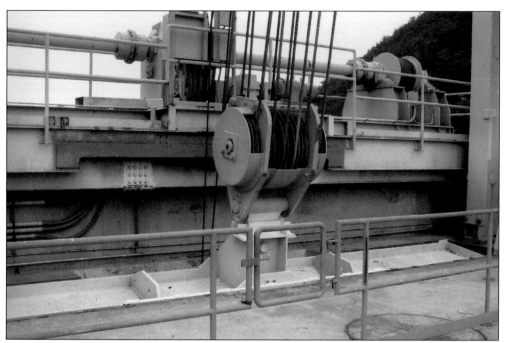

Pictured here is the apparatus used to raise and lower gates that allow water to enter the penstock tubes and flow to the turbines at Smith Mountain Dam. Shown above is part of the pulley system connected to the machinery in one of the hoist houses on top of the dam. The image below is a close-up of hoist houses on the lake side of the dam. When electricity is being generated, over 600,000 gallons of water pass through each turbine every second. As might be expected, fish from the lake also enter the penstock tubes when power generation occurs. However, the fish usually survive the trip as they have a natural tendency to relax and pass through the dam backwards. This reduces the risk of injury to the fish. (Both, author's collection.)

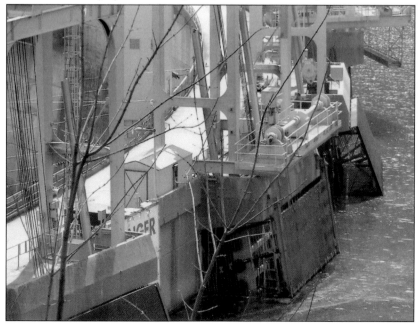

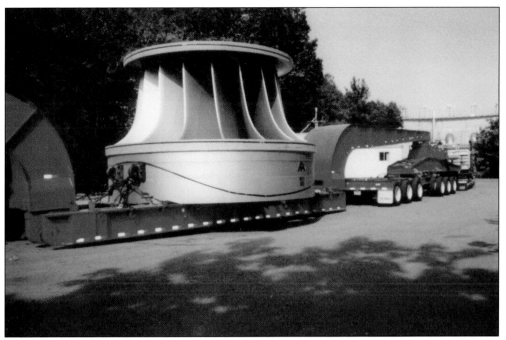

In these two photographs is a massive turbine that was brought to Smith Mountain Dam on a special carrier (above) in the late 1990s. Due to the enormous size of the turbine, the truck carrying it was escorted from the manufacturer in Pennsylvania to Virginia by state police. The carrier traveled only at night to minimize the effect on traffic, and the trailer was specially designed to adjust to uneven terrain so that the turbine was kept level. Upon arriving at Smith Mountain, it was discovered that the carrier was too large to enter the dam area, and the turbine was off-loaded to a smaller truck (below.) (Both, courtesy of Darrell Powell.)

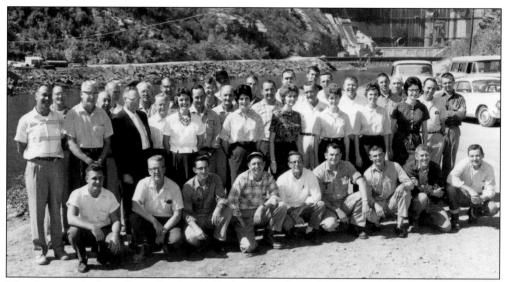

The photograph above, from October 1963, shows members of the AEP construction department. From left to right are (first row) Bobby Daniel, Ross Newell, Artis Barbour, Toby King, Gene Spitzer, Don Dudley, Dee Stanley, Jack Holbert, and Bob Morris; (second row) Dick Burt, Earle Snodgrass, C.C. Stanley, Georgia Hunt, Diane Brugh, Alyeene English, Betty Robinson, Joyce Crider, and Gene Sadler; (third row) Hale Terry, A.B. Carpenter, E.M. Ramsey, Jack Toler, Ralph Echols, J.D. Butler, Red East, John Coles, Jimmy Zeh, Jack Facemire, and Joe Divers; (fourth row) Howard Martin, Ralph Clester, Leroy Dalton, Ralph Mudgett, Jim Alley, Kenny Hern, Howard Huck, Bob Dillon, Bob Sadler, and Jim Sullivan. The photograph below, taken two decades later, shows AEP employees posing in front of the long-completed dam. Pictured are, from left to right, Gerald Cook, Chuck Edwards, Whitey Barbour, Kenny Worsham, John Ritchie, Jimmy Wertz, Mark Stewart, Jim Holland, Elton Quarles, Joe Plunk, Darrell Powell, Leroy Dalton, and Dale Fisher. (Above, courtesy of Georgia Snyder-Falkinham; below, courtesy of Darrell Powell.)

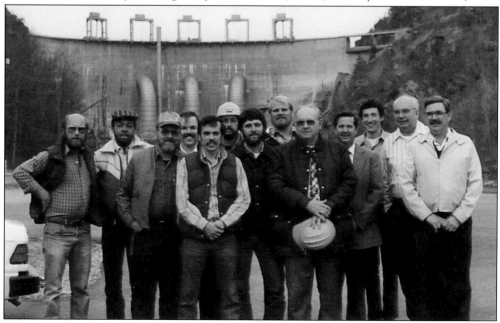

Six

WELCOME TO THE SMITH MOUNTAIN PROJECT

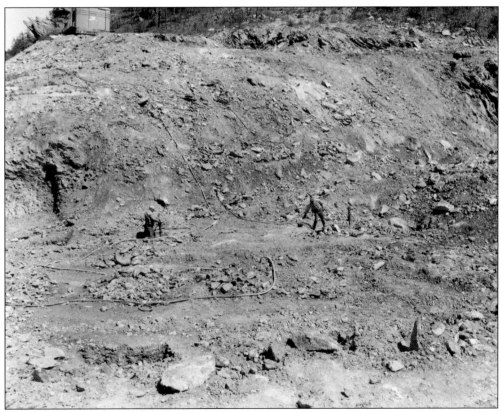

Pictured here on May 4, 1966, two workmen excavate and break up rock in preparation for the footers of the Smith Mountain Dam Visitors' Center overlook. Following completion of the dam, AEP wanted to provide a place for visitors to learn what the dam does and to provide a history of its construction. (Courtesy of AEP.)

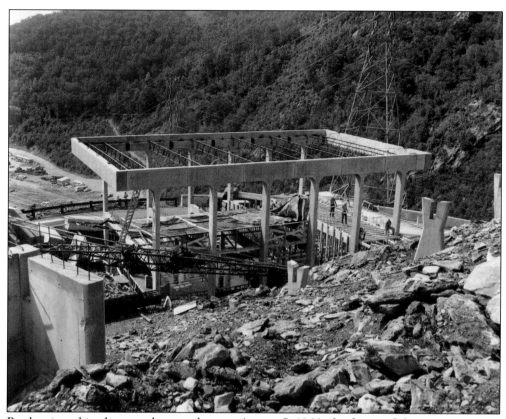

By the time this photograph was taken on August 5, 1966, the frame of the visitors' center could be seen. The braces in the foreground would eventually serve to support a ramp leading to the overlook area. Power lines running from the dam and down the gorge can be seen in the background. (Courtesy of AEP.)

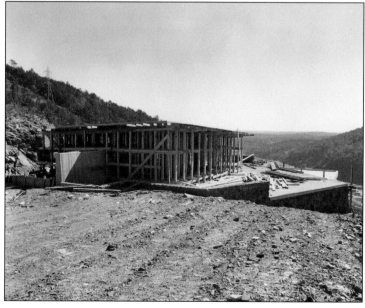

A later view of the visitors' center from October 8, 1966, reveals how much progress has been made since August. The foundation of the building now supports the inner braces for what will become the galleries and rooms of the center. Besides providing information about the Smith Mountain Project, the visitors' center also provides scenic views of the valley. (Courtesy of AEP.)

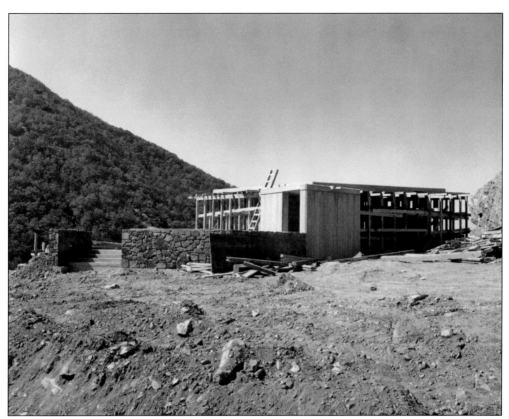

Another photograph from October 8, 1966, shows the entrance side of the visitors' center. The concrete used in the construction of the center was an appropriate choice given the subject of the information provided there. The flat roof of the building allows for an unobstructed view of the mountain scenery. (Courtesy of AEP.)

This photograph from November 16, 1966, gives a good perspective on the location of the visitors' center in relation to the overlook shelter. The almost completed visitors' center is in the center of the photograph, and the ramp to the right of the building leads to the shelter. (Courtesy of AEP.)

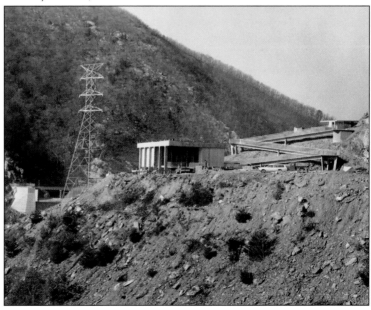

73

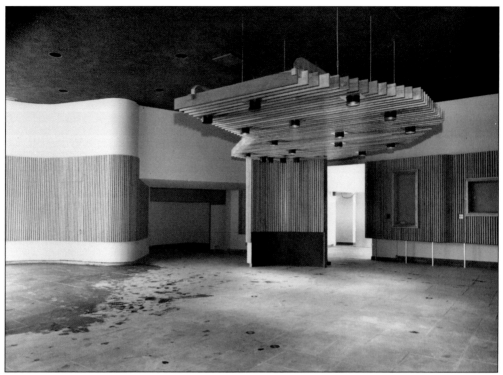

This is the interior of the visitors' center, probably the lobby, as it looked on March 8, 1967. Furniture and informative displays have yet to be installed. The curved walls and wooden light fixture look very modern, even by today's standards. (Courtesy of AEP.)

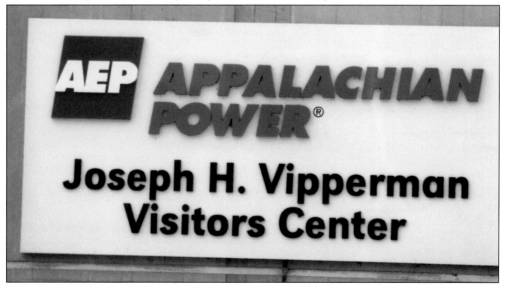

In early November 2011, the visitors' center was renamed in honor of Joseph H. Vipperman, following a renovation earlier in the year. A former president of APCO, Vipperman retired from the company after 40 years of service. He was AEP's vice president of shared services at the time of his retirement. A sign in the visitors' center lists all of Vipperman's accomplishments with the company. Admission to the Joseph H. Vipperman Visitors' Center is free. (Author's collection.)

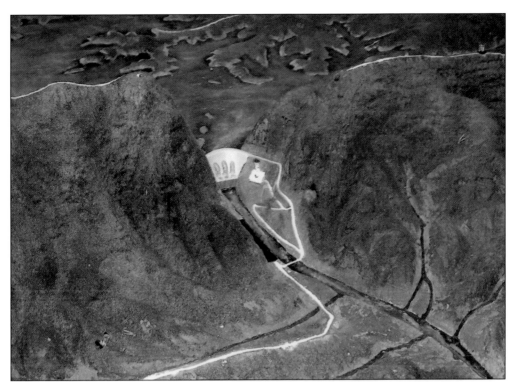

These contemporary photographs capture only a few of the interactive displays found in the visitors' center. Each year, schoolchildren from the surrounding counties visit Smith Mountain Dam and learn the purpose of the pump storage system. In the above photograph is a model of the dam, which allows visitors to get a sense of how hydroelectric power is produced. In the image at right, visitors can personally experience the expenditure of energy required to power different types of light bulbs. These types of displays help put the massive Smith Mountain Project into perspective. A film detailing the construction of the project can also be viewed at the visitors' center. (Both, author's collection.)

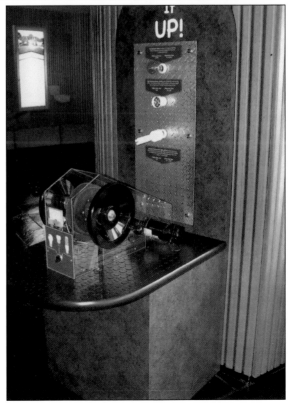

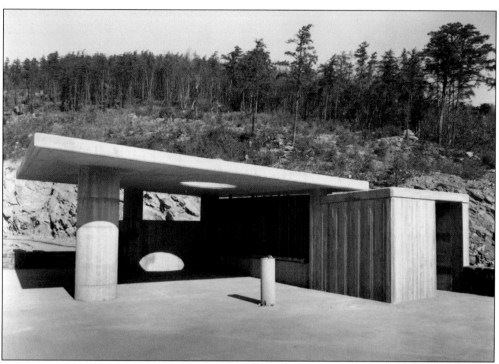

A ramp leads from the visitors' center up to the overlook seen in this photograph from November 1966. In addition to providing a rest stop following the climb up the ramp, the overlook provides a gorgeous view of the area. Visitors interested in bird watching and nature in general also enjoy the overlook and adjoining trail. (Courtesy of AEP.)

This photograph from the overlook fails to capture the true beauty of the area around Smith Mountain Dam. This view is looking downriver from the dam and provides a feel for how rural the area remains in many ways. The area is truly an outdoorsman's paradise. (Author's collection.)

A little up the trail from the overlook, visitors today have the opportunity to see the last remaining part of the construction cableway that was strung across the gorge during the building of Smith Mountain Dam. Shown here is a 500-ton head tower, which ran on banked rails and positioned the cableway so that a trolley on the cable could deliver construction materials using hoists. (Author's collection.)

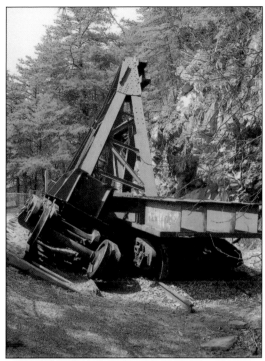

The operation of the head tower was directed from the work area via telephone. This unique apparatus served a vital role in the construction of the dam and made it possible to deliver the necessary building materials where they were needed, as they were needed. The weight capacity of the cableway was 20 tons. (Author's collection.)

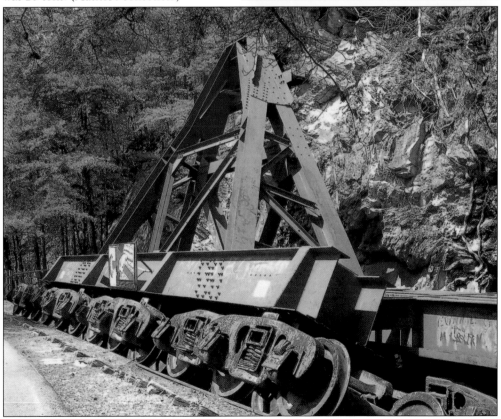

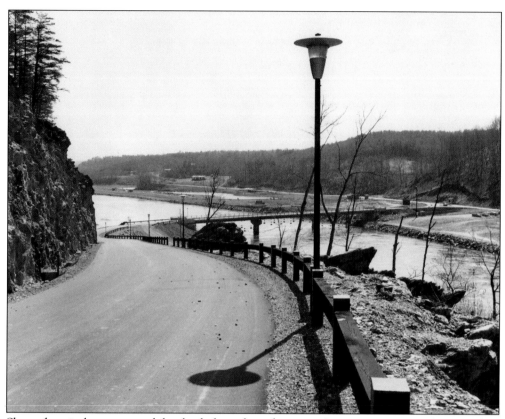

Shown here is the access road that leads down from the visitors' center as it appeared on March 8, 1967. Visible in the distance across the water is a picnic area built for visitors by AEP, downstream from the dam. In addition to being a source of hydroelectric power, AEP also encourages recreational use of the area. (Courtesy of AEP.)

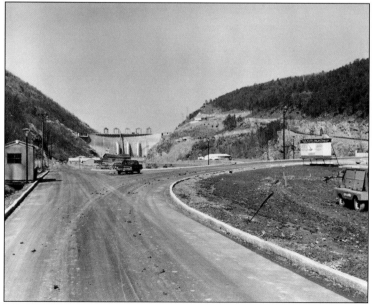

This view looking back toward Smith Mountain Dam was also taken on March 8, 1967. The photograph was taken just past the picnic area and provides a good look at the location of the visitors' center on the hill to the right of the dam. Employees' vehicles can be seen parked in the lot in the foreground. (Courtesy of AEP.)

Seven

ROADS AND BRIDGES

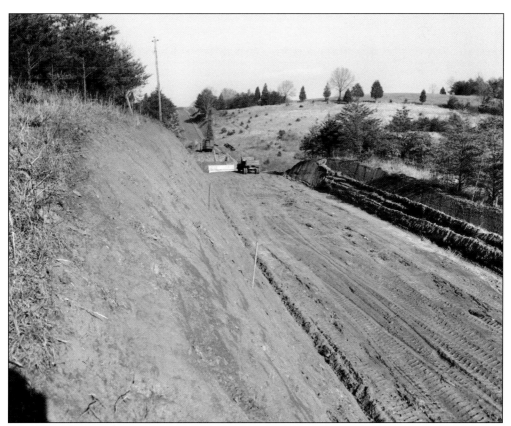

As part of the Smith Mountain Project, six new bridges and 22 miles of new roads were built. The rising waters covered old roads, and bridges had to be built, usually because the old bridges were too low or a bridge was needed where one had not existed before. In this photograph from November 1961, one can almost smell the dirt where construction vehicles have cut the road on Route 668 near the Gills Creek Bridge. (Courtesy of AEP.)

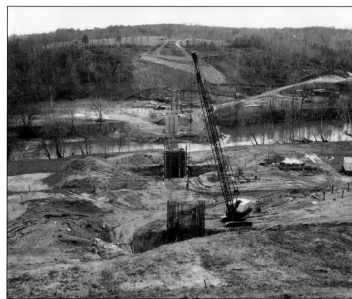

One of the most impressive bridges built as a result of Smith Mountain Lake was the new Hales Ford Bridge. Shown here is a general view of the initial stage of the bridge construction site on March 29, 1961. The Roanoke River can be seen passing peacefully by a crane and other construction equipment. (Courtesy of AEP.)

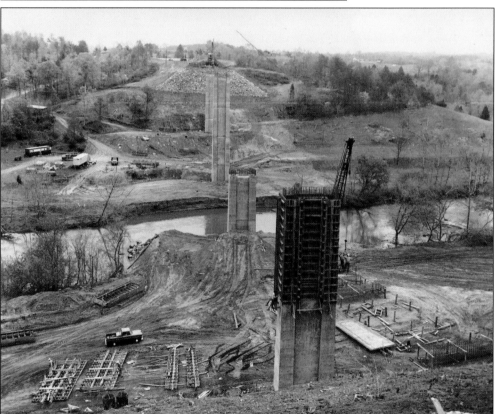

By the time this photograph was taken in May 1961, the concrete support piers for the new Hales Ford Bridge had grown considerably in height. Cranes were enlisted to assist in building the huge forms and later, installing the steel girders across the supports. Looking across the river into Bedford County, homes and farms can be seen in the distance. (Courtesy of AEP.)

Another image from May 1961 provides a view looking across the Roanoke River into Franklin County. The rural nature of this area has changed greatly over the past decades, and the gorge below the workers in the foreground is now completely filled by Smith Mountain Lake. (Courtesy of AEP.)

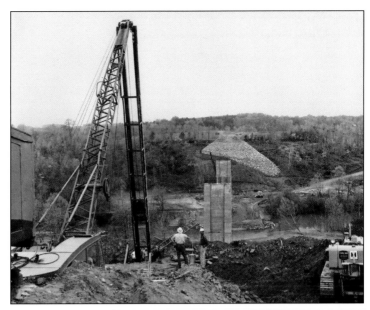

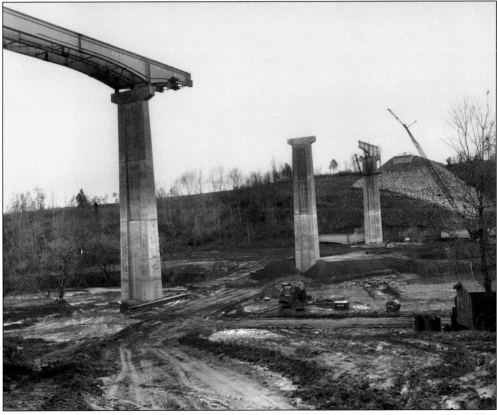

This photograph shows the east side of the new Hales Ford Bridge looking west toward Franklin County in January 1962. The "American Bridge" label on the girder refers to the American Bridge Company, which was founded in 1900 and has been involved in the construction of bridges and other projects all over the world. (Courtesy of AEP.)

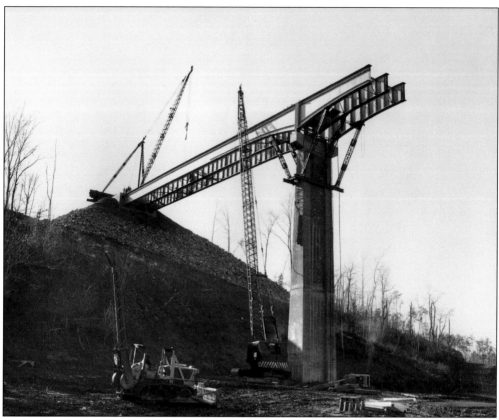

Looking up from the bank of the Roanoke River in February 1962, this photograph offers a great look at the beginnings of the west span of the new Hales Ford Bridge. This is also the Franklin County side of the bridge, and the bulldozer in the foreground gives a good scale reference to its height. (Courtesy of AEP.)

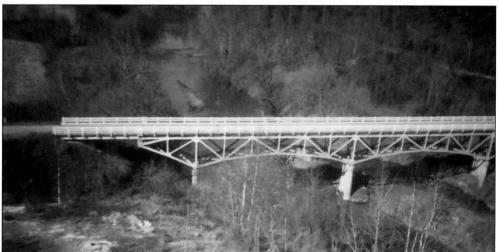

Here is a view of the old Hales Ford Bridge as seen from the new bridge in November 1963. The old bridge provided more than enough clearance for the Roanoke River to pass underneath but was nowhere near the height required by the new lake. (Courtesy of Carl W. Moyer.)

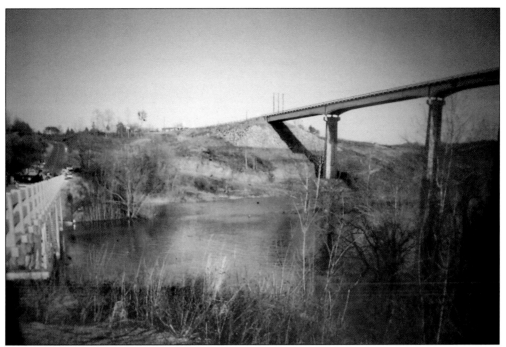

Above, a rare photograph from January 1964 shows both the old Hales Ford Bridge (left) and the new Hales Ford Bridge (right). The need for a higher bridge is still not evident but, judging by the partially submerged trees, the lake is clearly on the rise. In the image below, also taken in January 1964, vehicles can be seen parked on the old Hales Ford Bridge while their owners stand on the bridge and either look down at the rising lake or up toward the photographer on the new Hales Ford Bridge. Visitors to the area today will find it hard to believe that this scene ever existed. (Both, courtesy of Carl W. Moyer.)

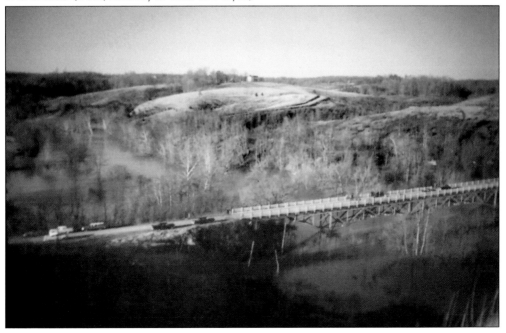

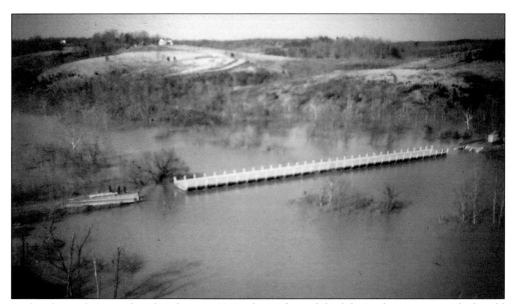

In the above photograph, taken later in 1964, the surface of the lake is almost even with the old Hales Ford Bridge, which had been partially dismantled. It was assumed that the old Hales Ford Bridge had been completely removed before Smith Mountain Lake filled to capacity. However, in 2009, a Rocky Mount real estate broker, J.D. Abshire, discovered that the old bridge remains under the lake. Abshire made the discovery using a sonar device on his fishing boat. AEP, which had performed bathymetric readings of the area to measure water depth and map the floor of the lake, was as surprised as anyone by Abshire's sonar images, as there was no prior evidence of the old bridge's existence. The markings on the image below mark the location of the old bridge in relation to the new bridge. (Above, courtesy of Carl W. Moyer; below, courtesy of J.D. Abshire.)

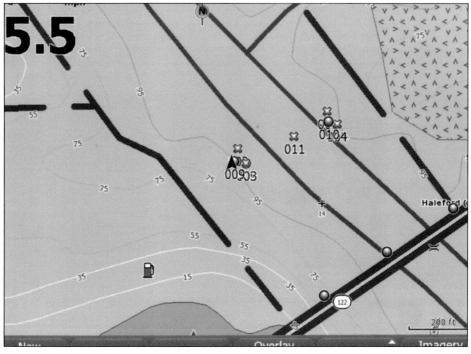

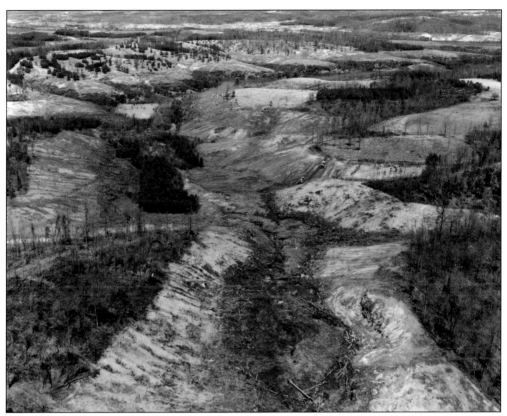

Taken near the Hales Ford Bridge construction site, this photograph shows clearing operations in 1964. The Roanoke River is near the top of the picture, and bulldozers can be seen near the center covering debris in an attempt to reduce the amount that will float freely in the lake. Logs and other debris yet to be covered can be seen in the foreground. (Courtesy of AEP.)

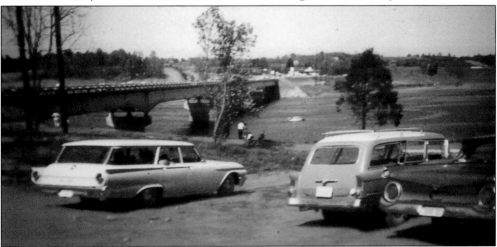

This 1965 photograph shows visitors admiring Smith Mountain Lake and the new Hales Ford Bridge on a sunny day. Smith Mountain Lake was only a matter of months from being completely filled by this time, and folks can already be seen enjoying boating and fishing. This view appears to be looking toward Bedford County. (Courtesy of Carl W. Moyer.)

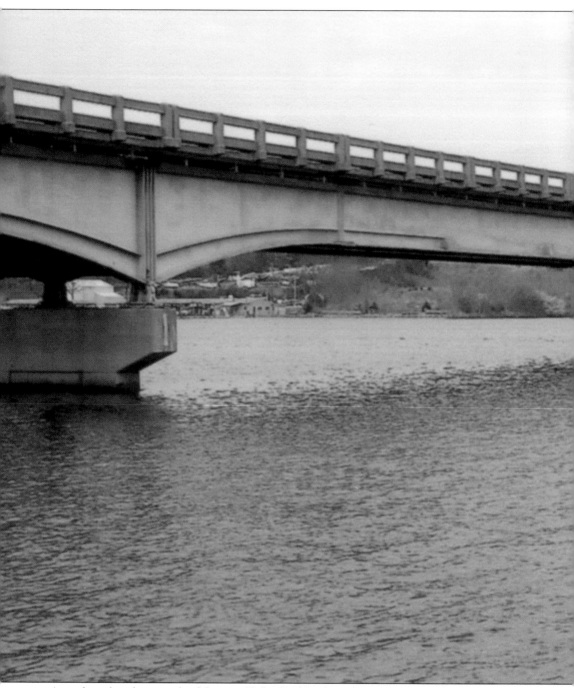

A modern-day photograph of the new Hales Ford Bridge taken in 2014 reveals just how high the lake rose when compared to the levels during the bridge's construction. This view is looking toward Bedford County, and marinas and other lake-related businesses can be seen in the distance. In recent years, the Virginia Department of Transportation has talked about replacing the bridge

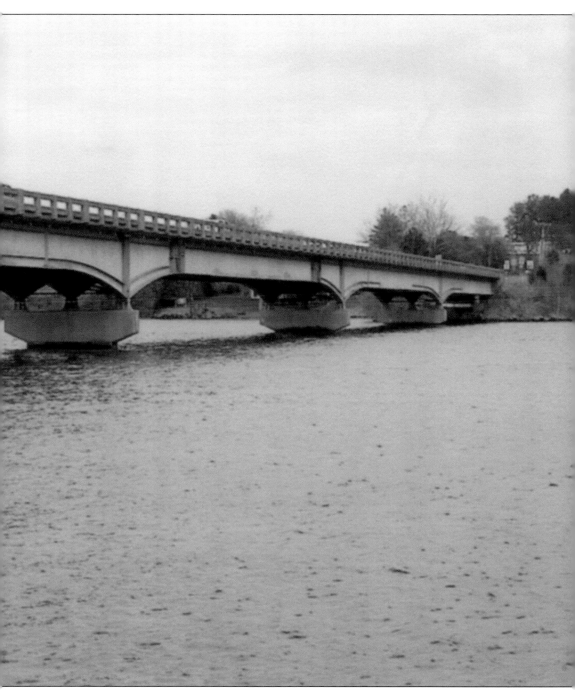

and building a new one with a larger traffic capacity. As Smith Mountain Lake has grown in popularity, traffic around the lake has increased, especially on major roads such as Route 122, which crosses the lake via the Hales Ford Bridge. (Author's collection.)

New bridges required new roads, and here is a portion of Route 668 cutting through farmland toward Gills Creek in August 1961. Views such as these also provide an idea of what the area looked like prior to the development caused by the dam and lake, and in fact, there is still plenty of scenic countryside in the Smith Mountain and Leesville Lakes areas. (Courtesy of AEP.)

A roller sits idle in this photograph of the north approach to the Gills Creek area on December 6, 1961. Residents who already lived in the lake area benefited from the improvements to county roads as well as the construction of routes around Smith Mountain Lake. (Courtesy of AEP.)

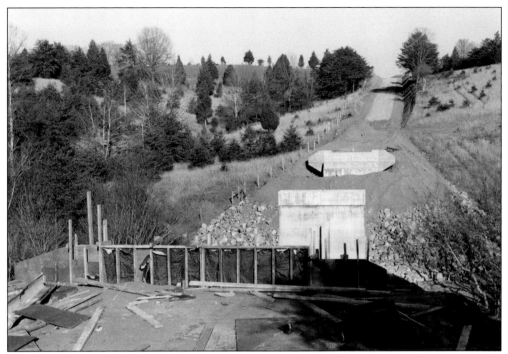

Taken in December 1961, the photograph above shows the initial abutment and piers construction of the Gills Creek Bridge. The rural setting of the image serves to remind workers that they not only had to be conscious of risks related to the work at hand, but also to be aware of any dangers posed by the natural environment. The photograph below chronicles the progress made at the Gills Creek Bridge project by early February 1962. Workers can be seen installing the framework of the bridge from the abutment to the support pier. (Both, courtesy of AEP.)

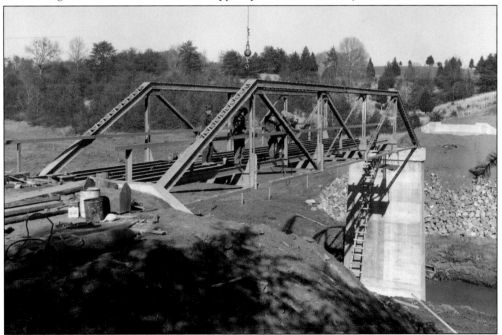

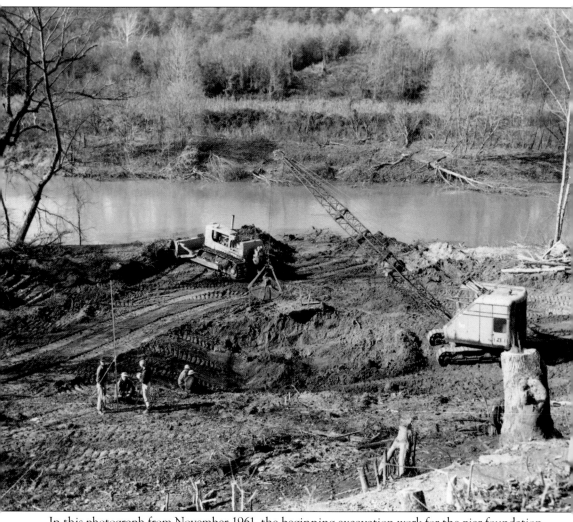

In this photograph from November 1961, the beginning excavation work for the pier foundation of the new Tolers Ferry Road Bridge can be seen. The bridge is located across a narrow part of the Leesville Lake downstream from Smith Mountain Dam. Workers appear to be in discussion regarding various parts of the project, which also required timber to be cleared. Meanwhile, a crane operator has been busy digging out a hole where a pier will be eventually erected. (Courtesy of AEP.)

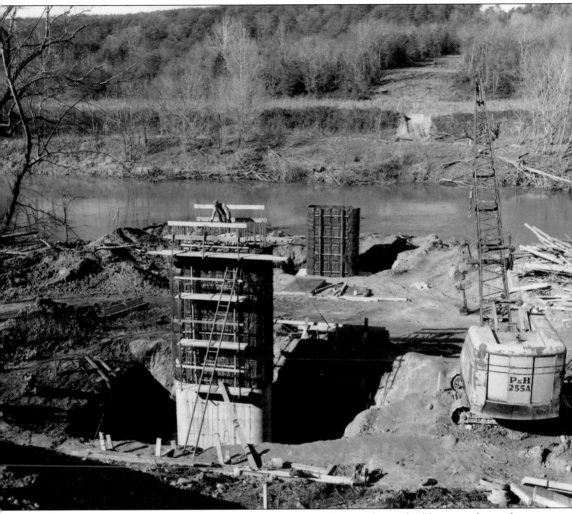

By the time this photograph was taken on December 1961, a good start had been made on the pier construction for the new Tolers Ferry Road Bridge. Again, just as with the new Hales Ford Bridge, the height of the support piers in the photograph give a good indication of just how much room was allowed for the water to rise. Note the construction worker on the pier in the foreground who has reached the top of the column via the tall ladder leaning against the pier. (Courtesy of AEP.)

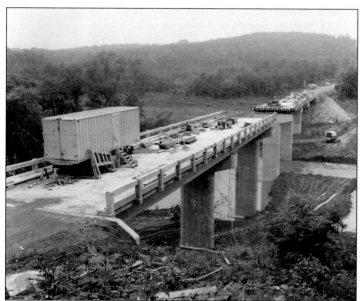

Tolers Ferry Road Bridge nears completion in this photograph from July 1962. Construction crews have attacked the project from both directions, and only the center section needs to be installed to join the two sides. Vehicles belonging to the workers can be seen parked on the side of the road in the background. (Courtesy of AEP.)

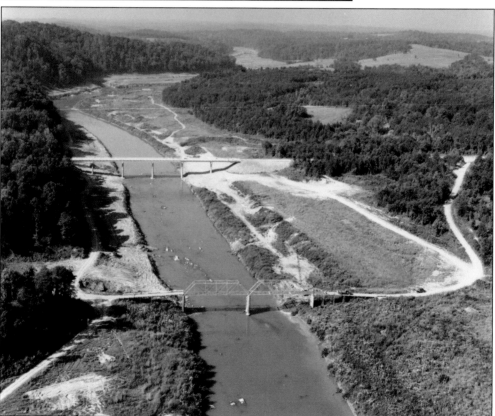

An aerial photograph from August 31, 1962, provides a look upstream in the direction of Smith Mountain Dam. In the foreground is the old Tolers Ferry Road Bridge, and the new bridge can be seen in the background. Access roads made by construction vehicles crisscross the landscape. (Courtesy of AEP.)

The support pier and framework of the new Hardy Ford Bridge were already in place when this photograph was taken in August 1961. The old bridge can be seen at right in the foreground, and a sign announces that travelers crossing from this side are leaving Bedford County and entering Franklin County. (Courtesy of AEP.)

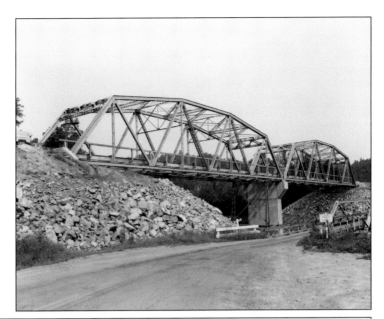

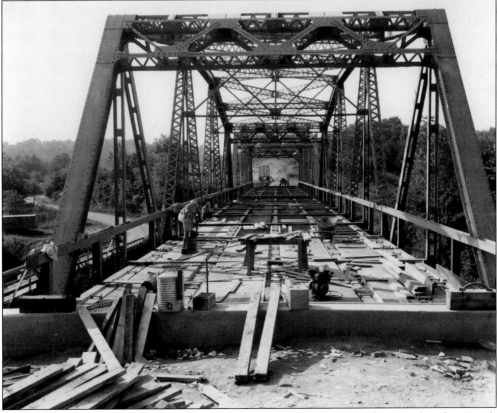

Work on the deck of the new Hardy Ford Bridge was well under way by the time this photograph was taken on September 13, 1961. Lumber and tools litter the area as construction workers ply their various skills in completing the job on a warm day. The older, lower bridge and road can be seen in the lower left corner of the photograph. (Courtesy of AEP.)

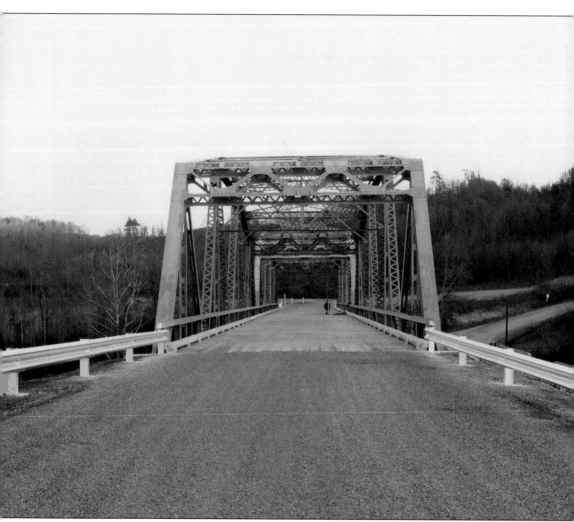

Pictured here is the completed Hardy Ford Bridge as it appeared on December 6, 1961. Some scaffolding appears to be standing on the right side of the bridge, but otherwise, the bridge looks ready for use. The bridge, which is located on State Route 634, is scheduled for replacement in 2016. In May 2012, the Virginia Department of Transportation used side-scan sonar to map the area under the bridge to aid designers in preparing plans for the replacement bridge. The cost for a new bridge is estimated to be approximately $4.6 million. (Courtesy of AEP.)

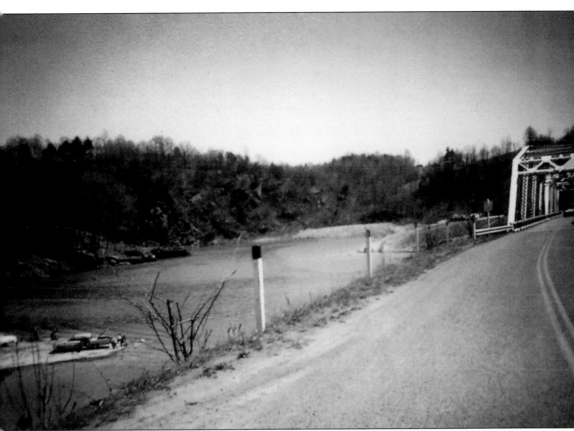

Folks appear to be fishing in the rising waters below the new Hardy Ford Bridge in the lower left of this image from 1964. The fact that they could drive their cars down to the water's edge probably made the experience more exciting and inviting. Other vehicles can be seen parked on the far bank near where Bay Roc Marina is now located. With the filling of Smith Mountain Lake, families were given more options for spending their leisure time and money. The surrounding counties have benefited as boat dealerships, sporting goods stores, marinas, and other businesses related to lake recreation activities have opened, creating jobs and tax revenue. (Courtesy of Carl W. Moyer.)

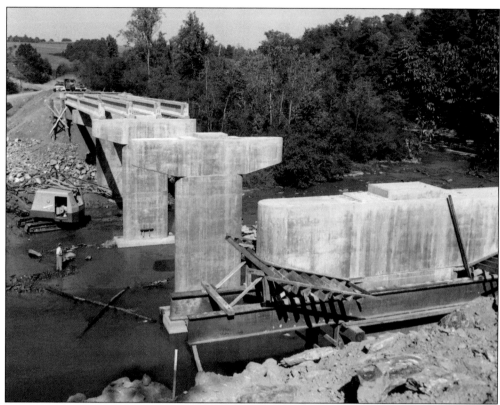

Shown in these two photographs is the construction of the Brooks Mill Road Bridge on State Route 834 near Wirtz, Virginia, in the fall of 1961. The above image captures the installation of pre-stressed concrete girders crossing the support piers of the bridge. Between the two support piers in the foreground, a worker is operating a bulldozer in the water. In the photograph below, men are working on the decking of the bridge on top of the concrete girders. The girders have not quite yet reached the far side bank where a bulldozer is parked. (Both, courtesy of AEP.)

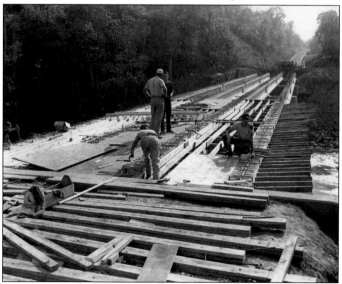

Eight

DEVELOPMENTS AND ATTRACTIONS

Businesses related to life at the lake have flourished over the years and none more than the real estate business. Pictured here in an advertisement from 1973 is Melvin S. Johnston, who came to the lake in 1968. Johnston, in addition to being a real estate broker, was a philanthropist and founded the Smith Mountain Lake Association. He passed away in Hedgesville, West Virginia, on October 27, 1998. (Author's collection.)

WELCOME TO SMITH MOUNTAIN LAKE!

LAKESIDE REALTY

Melvin S. Johnston Invites You To Take The Grand Tour

The cool blue waters of Smith Mountain beckon the world weary, the adventurous, and the connoisseur of quality living. Refreshment lies within the sphere of this sparkling Central Virginia gem whose myriad fingers extend into shadowy coves and sunlit beaches. The staff of Lakeside Realty is at home among the towering pines and mossy slopes that encircle the sun-gilded waters of the state's largest lake encompassing 20,000 acres with a 500-mile shoreline. Whether your dream is of a forest, green and leafy, or a sand pebble beach close by the water's edge, you'll discover it sooner by allowing our trained Lakeside Realty staff to show off "our" lake to its best advantage. Let us interpret your dream of pleasure, beauty and relaxation and help you to transform it from the ethereal to the real thing.

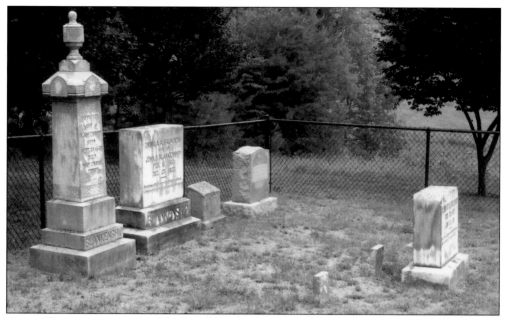

Pictured here is an example of the small family cemeteries that are found all over the rural areas of the counties surrounding Smith Mountain Lake. These old cemeteries posed a challenge with the installation of Smith Mountain and Leesville Dams in that some cemeteries were located in the future reservoir areas. Relocation efforts resulted in some 1,100 graves, many marked only with flagstones, being moved to safer locations. (Author's collection.)

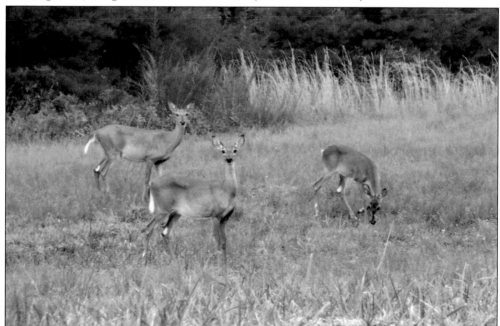

Although modern conveniences and the amenities of home are easily found at Smith Mountain Lake, the area has retained its country flavor and charm. Various types of wildlife are in abundance around the lake area and attract both naturalists and sportsmen. These whitetail deer were photographed grazing in a meadow near the Compass Cove development. (Author's collection.)

Recreation at Smith Mountain Lake comes in many forms and knows no age limit. Pictured here are Elsie Wood Moyer and her son Gene Elisha Moyer, spending time together on a Jet Ski. The photograph was taken about 1997 near Magnum Point Marina in Penhook, Virginia. Elsie Moyer was born in 1920 and passed away in 2001, and Gene Moyer was born in 1942 and passed away in 2014. (Courtesy of Carl W. Moyer.)

One of the attractions of lakefront living is the ability to access the lake at will. Not all residents live at the lake year-round, and some are summertime-only visitors. However, having a boat or Jet Ski parked at a dock behind the home is a water lover's dream come true! (Author's collection.)

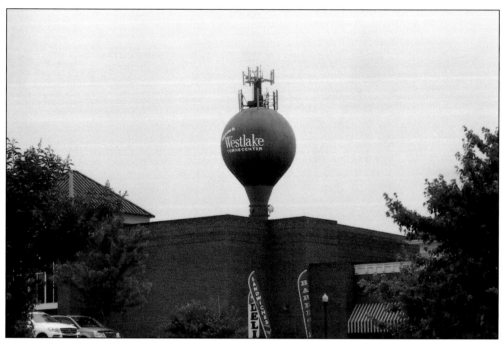

One of the areas near Smith Mountain Lake that has really taken off and is thriving is the Westlake Corner community in Franklin County. Retail stores and restaurants allow lake residents easy access to necessities and conveniences without requiring a long drive to distant towns and cities. The Westlake Towne Center (above and below) was developed by the Willard Companies and has a Kroger, movie theater, building supply store, liquor store, and jewelry store, among various other restaurants and businesses. With plenty of room for expansion, continued economic growth seems certain. The 2010 census listed the population of Westlake Corner as 976, and the median age of residents was 53.9 years. The estimated average domicile value in Westlake Corner in 2012 was $466,362. (Both, author's collection.)

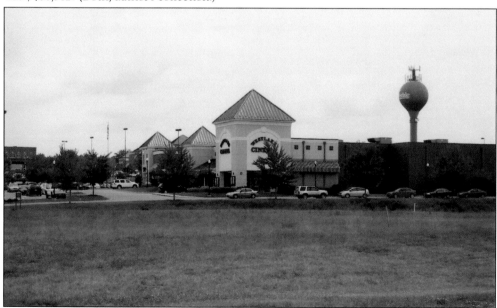

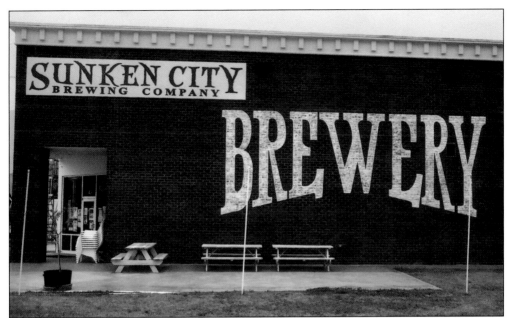

Another popular attraction at Westlake Towne Center is the Sunken City Brewery, which is owned and operated by Jerome Parnell III. The name, Sunken City, is a reference to the community of Monroe that was flooded when Smith Mountain Lake was filling. The 8,800-square-foot microbrewery contains a brew house, fermentation area, canning room, and taproom. There is also an outdoor beer garden. The taproom features a wall mural of the lake overlaying an older map of the areas flooded by the lake. The brewery broke ground for construction at Westlake on August 30, 2012, and held its grand opening ceremony on May 10, 2013. The business offers several beers, including Dam Lager and Red Clay IPA. (Both, author's collection.)

Located on the north shore of the lake in Bedford County is Smith Mountain Lake State Park. Consisting of 1,248 acres, the park offers an assortment of activities from the water to the forest. There are several miles of hiking trails throughout the park, with varying degrees of difficulty. In addition, there are boat and cabin rentals as well as sites for camping. Many visitors to the park take advantage of the fishing and sightseeing opportunities presented along the shoreline in addition to the boat slips shown below. A visitors' center contains informative displays concerning the lake and area history. (Both, author's collection.)

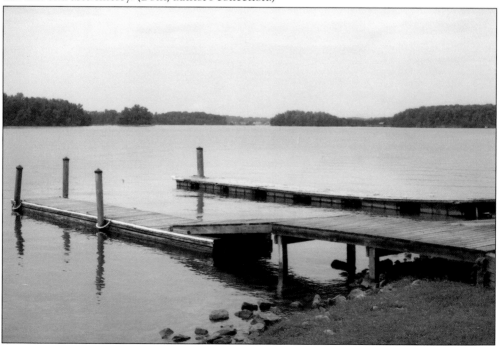

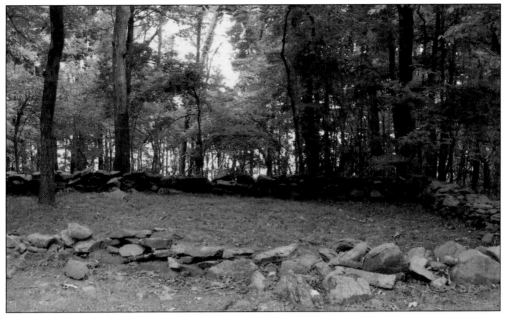

Also located in Smith Mountain Lake State Park is the site of the restored foundation of the Moody Meeting House (above). The Moody Meeting House was home to one of the first Baptist churches in the area, Staunton Baptist Church. The church's first pastor was William Johnson, and the first meeting was held on April 11, 1790. At the time, the nearby section of the Roanoke River was known as the Staunton River, from where the church got its name. The log meetinghouse was approximately 30 feet by 18 feet. In the spring of 1877, the church relocated due to the loss of members and the failing condition of the building. The congregation of the modern Staunton Baptist Church dedicated a historical marker (below) at the original site on May 20, 1984. (Both, author's collection.)

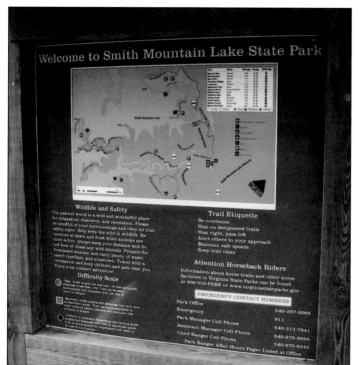

This sign at Smith Mountain Lake State Park provides visitors with information regarding the availability and difficulty of the park's 13 hiking and biking trails. It also serves as a reminder that the area is still home to various species of wild animals, some meriting a wide berth if encountered. Immediately to the left of the sign is a fishing pier at the park. (Author's collection.)

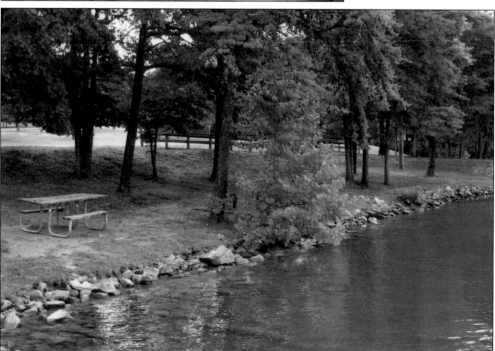

A picturesque and inviting scene at Smith Mountain Lake State Park includes one of the many picnic areas available there. Those taking advantage of all the park has to offer usually find themselves relaxed after a day of boating, hiking, biking, or fishing. Naturalists enjoy seeing the various plants and animals easily found within the park. (Author's collection.)

Smith Mountain Lake is in the top five on the list of places to take out-of-town visitors when they come to the area. Seen here enjoying a boat ride in 2005 are, from left to right, Daryl Puryear, Kristy Puryear, and Blake Pennington from North Carolina, along with their hosts Faye and Bobby Moyer of Franklin County. (Courtesy of Carl W. Moyer.)

Family picnics at the lake are especially popular during the summer months when the scorching heat can easily be cured with a quick dip in the cool water of Smith Mountain Lake. Judging by the heavily laden table in this photograph from the mid-1980s, a fine time was had by all. (Courtesy of Cindy McCall Cundiff.)

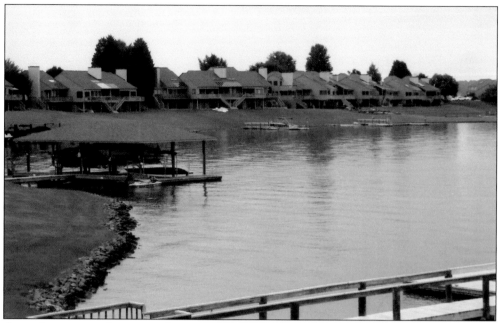

A popular vacation destination for visitors on the Franklin County side of Smith Mountain Lake is Bernard's Landing. The 70-acre resort offers a variety of ways to enjoy the lake and features condominiums and townhouses for rent. This photograph shows some of the rental lodgings available and their close proximity to the lake. (Author's collection.)

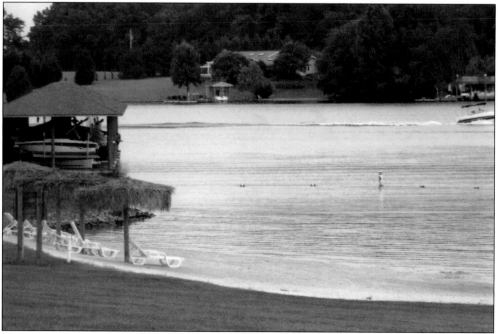

Bernard's Landing also has a conference center and an award-winning restaurant that play host to meetings, weddings, banquets, and other special events. The complex was one of the first resorts developed on Smith Mountain Lake. Shown here is one of the beaches at Bernard's Landing, which provides a tranquil view of the lake. (Author's collection.)

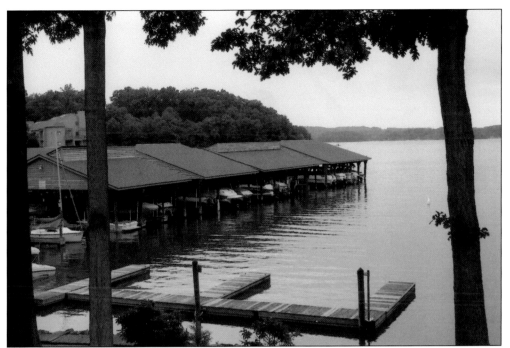

For boating enthusiasts, Bernard's Landing offers docks easily accessible from the residence units (above). Guests can bring their own watercraft or rent them from the resort. Everything from ski boats to canoes and kayaks are available. The resort also offers areas where visitors can take relaxing walks and enjoy the natural beauty that has resulted from the man-made lake (below). The tourism industry created by Smith Mountain Lake has not only benefited resorts such as Bernard's Landing, but has also helped outlying businesses and attractions as visitors venture out to explore the area. (Both, author's collection.)

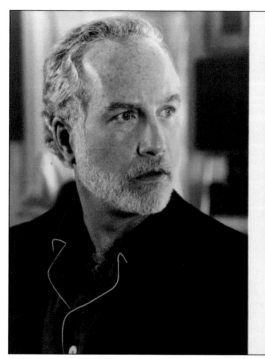

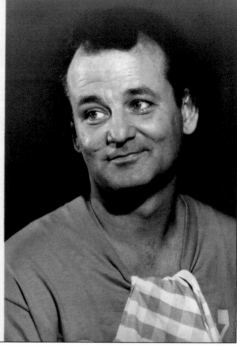

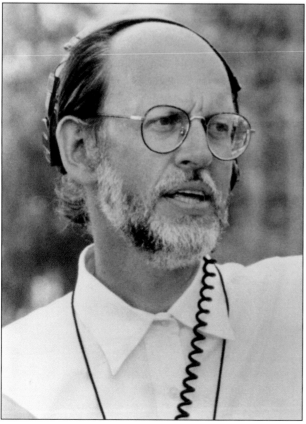

The natural beauty and accessible location of Smith Mountain Lake has not escaped the attention of Hollywood. In August 1990, filming began for the motion picture *What About Bob?* The movie starred Richard Dreyfuss (above left) and Bill Murray (above right). The film's concept originated from an idea that screenwriter Alvin Sargent came up with during a conversation with a friend whose husband was a psychiatrist. Sargent asked if any of her husband's patients ever followed him around, and this idea proved to be the basis for *What About Bob?* The movie was directed by Frank Oz (left), who also directed *The Muppets Take Manhattan* and *Dirty Rotten Scoundrels*, among other films. As an actor, Oz has appeared in several movies, including *The Blues Brothers* and three of the *Star Wars* films, in which he voiced Yoda. (Both, © Touchstone Pictures. All Rights Reserved.)

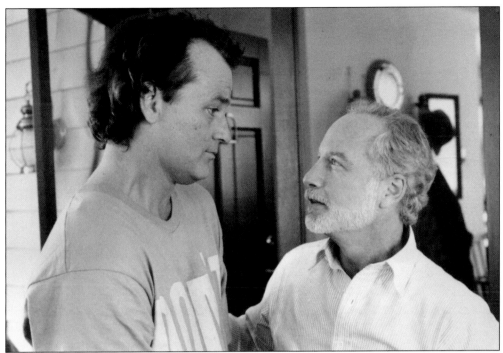

What About Bob? is the story of psychiatrist Dr. Leo Marvin (Richard Dreyfuss) seeking an enjoyable vacation with his family at Lake Winnipesaukee (Smith Mountain Lake). The doctor's vacation plans are completely altered when his dependent patient, Bob Wiley (Bill Murray), shows up at the lake. The filmmakers chose Smith Mountain Lake because it still had the feel of a summer resort area even as the fall season approached during filming. In addition, a lakefront house was found that was near Bernard's Landing, making the location even more attractive. Shown on this page are two scenes from the movie that were shot at the lakefront house. (Both, © Touchstone Pictures; All Rights Reserved.)

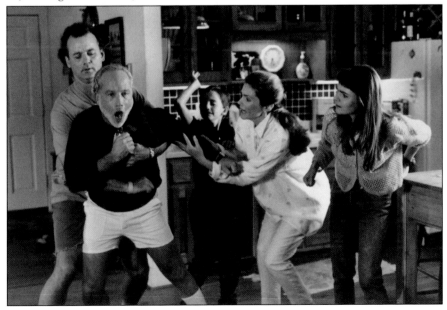

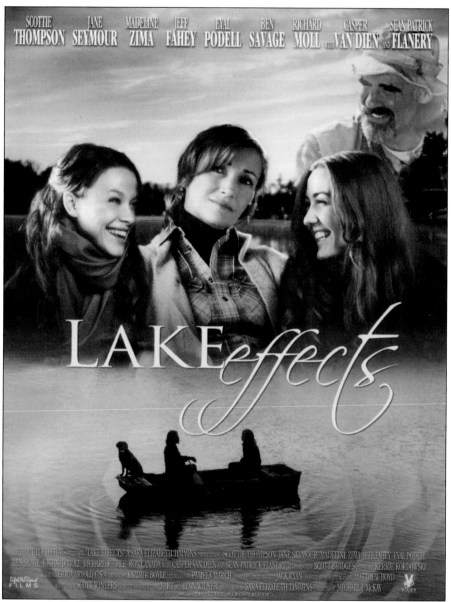

In mid-2010, Life Out Loud Films began shooting the movie *Lake Effects* at Smith Mountain. The film starred Scottie Thompson, Jane Seymour, Madeline Zima, and Jeff Fahey. *Lake Effects* is the story of Sara (Scottie Thompson), a successful attorney who lives in the city and has been given the most important case in her career when she learns her father (Jeff Fahey) has passed away. Sara then returns home to Smith Mountain Lake to be with her mother (Jane Seymour) and sister (Madeline Zima). After returning home, Sara finds that her father left behind a large bank debt, and she works to save the family's lake house. Sara also eventually learns that her boyfriend in the city is involved with the bank and her law firm in illegal activity. With guidance from her father's spirit, Sara confronts the reasons she originally left the lake and is able to save the family home while also reconnecting with an old boyfriend and her love for the lake. *Lake Effects* first aired on the Hallmark Movie Channel on May 19, 2012. (Courtesy of Life Out Loud Films; © SML Lake Effects LLC, All Rights Reserved.)

The producers of *Lake Effects* have stated the idea for the film was inspired by Smith Mountain Lake and the communities found there. The lake community embraced the filmmakers, and several in the area allowed use of their homes and businesses in the movie. In a scene from the production, Jeff Fahey is shown fishing from a bank on Smith Mountain Lake. (Courtesy of Life Out Loud Films; © SML Lake Effects LLC, All Rights Reserved.)

Lake Effects made Smith Mountain Lake one of the stars of the movie. The film was totally financed by people connected to the local lake area, and many locals donated their time to assist with the making of the film. In another scene from the movie, Jane Seymour as "Vivian" (center) comforts her two daughters. (Courtesy of Life Out Loud Films; © SML Lake Effects LLC, All Rights Reserved.)

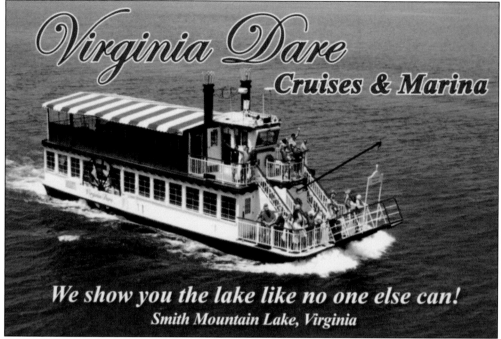

We show you the lake like no one else can!

Smith Mountain Lake, Virginia

Another popular attraction at Smith Mountain Lake is the *Virginia Dare* cruise boat in Bedford County (above). The boat was built in La Crosse, Wisconsin, in 1989 and is a replica of a 19th-century side-wheeler. The *Virginia Dare*'s journey to the lake was delayed for several days outside of Roanoke, Virginia, as a result of the combined weight of the boat and the carrier hauling it being above the limit for a bridge that had to be crossed. A solution was found by unloading the boat and allowing the carrier to cross before reloading the boat using a crane. The *Virginia Dare* celebrated 25 years at the lake on June 24, 2014. The Portside Grill & Bar at the boat's marina (below) is the only grill and bar over the water at the lake. (Above, courtesy of *Virginia Dare* Cruises & Marina; below, author's collection.)

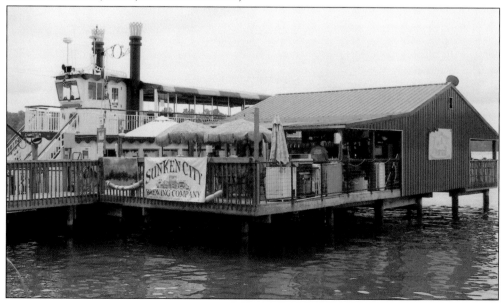

The *Virginia Dare* offers dining as well as specialty cruises on Smith Mountain Lake. In the photograph above, all is ready for the bride and groom as a wedding is set to take place on board. Below, the dining area is decorated and awaiting wedding guests to arrive for the reception dinner. *Virginia Dare* Cruises & Marina also organizes the Flotilla for Toys Boat Parade of Lights each year in association with Lake Christian Ministries. The *Virginia Dare* leads other lighted and decorated vessels from her marina to Hales Ford Bridge and back in November or December. The event is held to provide toys for local children in need at Christmas. (Both, courtesy of *Virginia Dare* Cruises & Marina.)

Approximately four miles from the Hales Ford Bridge is the Booker T. Washington National Monument in Franklin County. The park is 239 acres and includes most of the original 209 acres of the Burroughs' plantation where Washington was born into slavery on April 5, 1856. Booker T. Washington National Monument features a visitors' center as well as reconstructed farm buildings along winding pathways. Area schoolchildren often take field trips to the monument to learn about rural life on a Southern farm during the Civil War. The park offers live demonstrations on occasion where life on a Virginia plantation can be observed firsthand. Admission to the monument is free, and it is a worthwhile stop for anyone interested in American history. Booker T. Washington National Monument is located at 12130 Booker T. Washington Highway in Hardy, Virginia, and was established in 1957. (Author's collection.)

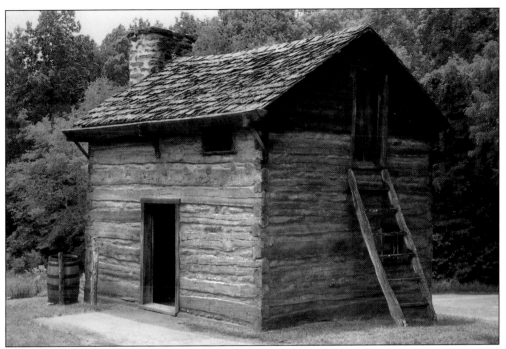

The home of the plantation owners, James and Elizabeth Burroughs, is no longer standing. Pictured here is the exterior (above) and interior (below) of the reconstructed slave cabin where Washington was born. In his autobiography *Up From Slavery*, Washington recalled that not only was the cabin home to his family, but it also served as the kitchen for the plantation where his mother, Jane, was the cook. The cabin did not have glass windows, and there were cracks around the ill-fitting door frame. Washington wrote, "While the poorly built cabin caused us to suffer with cold in the winter, the heat from the open fireplace in summer was equally trying." Washington and his family lived here until they moved to West Virginia at the end of the Civil War in 1865. The floor of the cabin was dirt, and the board-covered hole in the floor seen in the image below was used to store sweet potatoes during the winter. (Both, author's collection.)

Visitors to the Booker T. Washington National Monument are able to get a feel for the rugged way of life on a 19th-century farm. In the foreground of the photograph above are split rail fences, while livestock pens can be seen under the copse of trees. The monument also has a replica tobacco barn for visitors to view, and other recreated structures include a blacksmith shed and horse barn. On occasion, interpretive demonstrations featuring reenactments of events and activities from Washington's time on the plantation are held. In the photograph below, a general view of a pasture area encompasses fenced-in spaces where horses and cattle were kept. Although slaves were commonly viewed as property by their owners, Washington wrote of the Burroughs family with compassion in his autobiography. (Both, author's collection.)

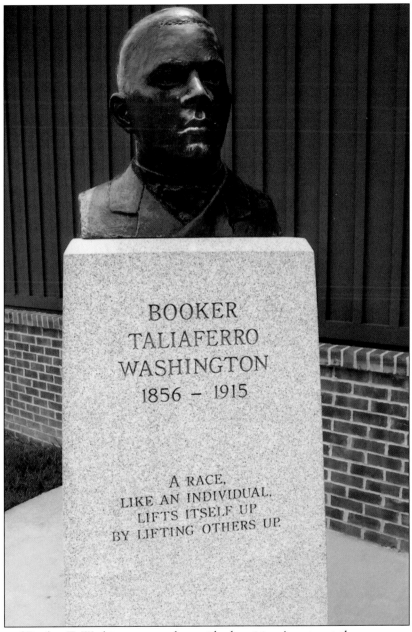

BOOKER
TALIAFERRO
WASHINGTON
1856 – 1915

A RACE,
LIKE AN INDIVIDUAL,
LIFTS ITSELF UP
BY LIFTING OTHERS UP.

This bust of Booker T. Washington stands outside the visitors' center at the monument. In his autobiography, Washington recalled hearing that his father had been a white man from a nearby farm, but Washington never met him. After the end of the Civil War, Washington, his mother, and their family joined Washington's stepfather in West Virginia. Washington demonstrated a voracious desire for an education and eventually was able to attend Hampton Institute, where he later taught. In 1881, he founded a secondary school for African Americans that is now Tuskegee University. Washington was considered one of the most influential African Americans of his day and promoted racial equality and better educational opportunities for his people. One of his best-known sayings is, "Those who are happiest are those who do the most for others." Washington died on November 14, 1915, and was buried on the campus at Tuskegee. (Author's collection.)

This advertisement for the Pelican Point Family Campground from the early 1970s is representative of the various outdoor-themed businesses given life by Smith Mountain Lake. At the time that this advertisement ran, Bill and Evelyn Giles owned and operated the campground. The business has since grown and expanded into the Pelican Point Yacht Club, open year-round. The club is one of the largest marinas on Smith Mountain Lake, with 134 protected deepwater slips for boats. The business has been owned and operated by Ralph and Ginny Zahn since 1974 and covers 18 acres. Pelican Point Yacht Club offers members amenities such as a 3,000-square-foot clubhouse, swimming pool, bathhouse, tennis courts, shuffleboard, ship's store, and picnic areas. The club also features a service yard for boat cleaning and maintenance. The telephone number for the club remains the same with the exception of the area code, which is now 540. (Author's collection.)

One of the most popular sports at Smith Mountain Lake is, of course, fishing. The lake contains several species of fish, including largemouth and smallmouth bass, striped bass, crappie, catfish, sunfish, muskies, and white and yellow perch. A high concentration of black bass is found near Hales Ford Bridge, while striped bass are distributed fairly evenly throughout the lake. In the photograph at right, Barry Cundiff (left) poses with the striped bass he caught during the Cave Spring Optimist Club's fishing tournament in 1980. His then girlfriend and now wife, Cindy (McCall) Cundiff, is to the right of the fish. Her brother T.W. McCall stands above them. Shown below are the other fish caught during the tournament. Cundiff's catch placed second in the contest and now is mounted and displayed in his Glade Hill home. (Both, courtesy of Cindy McCall Cundiff.)

The natural beauty of Smith Mountain Lake makes it easy to forget that it has not always been there. It is hard to picture what the area looked like before the dams were built. This photograph shows the area of the lake just beyond the *Virginia Dare* Cruises & Marina in Bedford County. (Author's collection.)

Beautiful coves such as this one at Smith Mountain Lake State Park can be found all over the lake, and many of these areas can be accessed by hiking trails. Over the years, photographers have discovered the beauty of the area and have produced some outstanding work. (Author's collection.)

The W.E. Skelton 4-H Educational Conference Center in Franklin County is one of the nation's premier 4-H facilities. The 4-H center was founded in 1966 and is located on property donated by AEP. Over the years, the facility has grown and expanded from its humble beginnings and has served over 145,000 youth to the present. On September 9, 2004, the name of the center was changed from the Smith Mountain Lake 4-H Educational Conference Center to honor Dr. William E. Skelton for his many years of service to the region's young people. Dr. Skelton served on the center's board for approximately 30 years and was, at one time, the director of Virginia Cooperative Extension and dean of the College of Agriculture and Life Sciences at Virginia Tech. Dr. Skelton passed away in 2008. The 4-H center's primary focus is to provide a safe and child-friendly facility where high-quality programs are available to the region's youth. (Author's collection.)

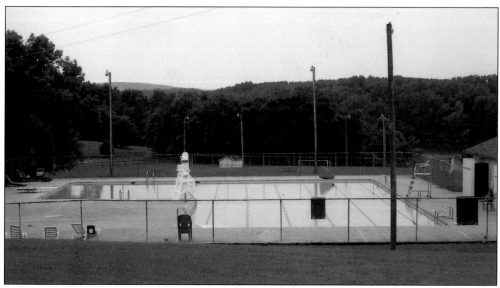

The Skelton 4-H Center is responsible for serving young people in 19 counties and 2 cities in western, central, and southwestern Virginia. The center's mission is "to provide dynamic, research-based, hands-on learning experiences for 4-H youth, other youth, and adults that will enable them to become self-directed, contributing, and productive members of society." Pictured here are two of the activity options offered at the 4-H center: swimming (above) and archery (below). In addition to 4-H–related events, the center is also available for retreats, weddings, and conferences. The center offers six centrally located lodges, which provide 437 beds for guests. (Both, author's collection.)

Shown above is the Willard Amphitheater located on the grounds of the Skelton 4-H Center. The amphitheater was dedicated on June 29, 2006, in honor of Ron Willard, who serves on the center's board. In addition to 4-H–related activities, the amphitheater is also used for fundraising and entertainment events. Since the center is located on Smith Mountain Lake, various water as well as land-based activities are offered. These include fishing, canoeing, kayaking, hiking, camping, and rock climbing. In the photograph below, the Advance Auto Parts Gazebo and Dock overlook the water on the point at the Skelton 4-H Center. The gazebo provides a beautiful and peaceful view of the lake. (Both, author's collection.)

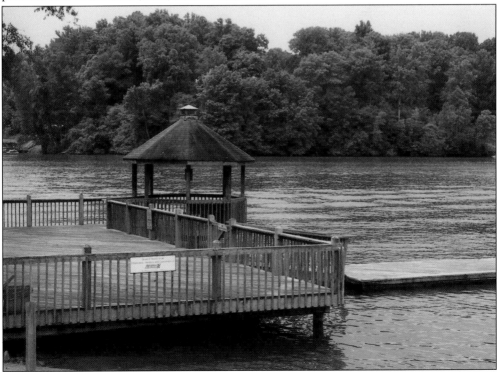

The Canadian geese seen above seem to be debating whether or not the posted rules at the Skelton 4-H Center apply to them. As with most areas around the lake, there is an abundance of wildlife on the center's grounds. The center's Discovery and Explorers Programs both provide educational and interactive classes involving wildlife. (Author's collection.)

Pictured here is the Bridgewater Plaza, which is located just before the Hales Ford Bridge on the Franklin County side of the lake. The plaza is an example of the one-stop type retail centers often found in resort areas. In addition to retail, dining, and entertainment opportunities, Bridgewater Plaza is also the home of the official Smith Mountain Lake Visitors' Center. (Author's collection.)

In an image from November 1962, oil circuit breakers (OCBs) in a substation switchyard serve as a reminder of the primary reason for the Smith Mountain Project—the production of hydroelectricity. However, the economic and societal benefits that have resulted as a by-product of the creation of Smith Mountain and Leesville Lakes continue to expand as the area grows in popularity. (Courtesy of AEP.)

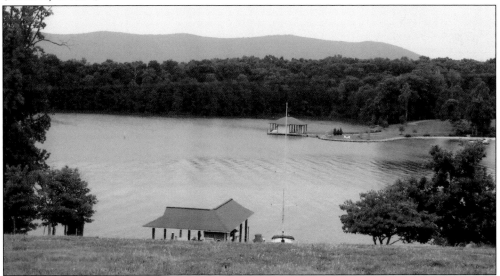

Surrounded by the mountains of southwestern Virginia, Smith Mountain Lake provides an ideal setting for those wanting to experience country lake living. Private docks such as these can be found in residential areas where each home has a lake in the backyard. A buoy bobbing in the water on the left side of the photograph lets boaters know to reduce their speed. (Author's collection.)

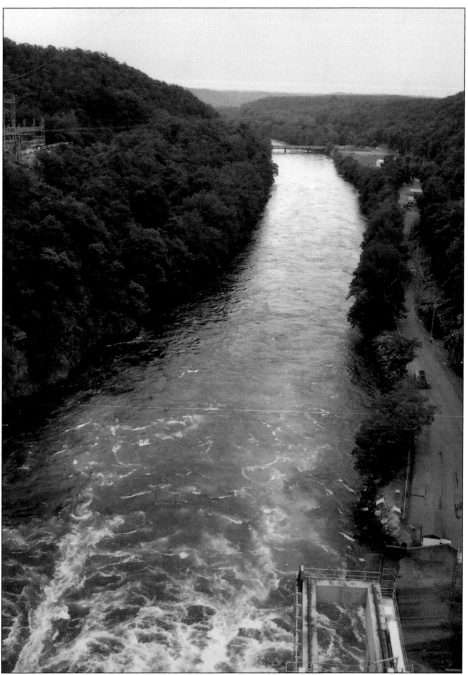

On a summer day, churning water can be seen on its way into the Leesville reservoir after exiting turbines at Smith Mountain Dam. With a few exceptions, this part of the pump storage system looks much like it did before the dams were built. The narrowness of Leesville Lake at this point presents more of a river appearance than that of a reservoir. Even after more than 50 years, the Smith Mountain Project continues to be a jewel in the AEP system and looks to remain so, well into the future. One can only imagine what the former owners of the long ago submerged farms and fields would think of their rural area now. (Author's collection.)

BIBLIOGRAPHY

Hancock, Frank. "From A Wilderness River To A Hydroelectric Plant–The Job Took 5 Years." Roanoke, VA: *Roanoke World-News*, date unknown.

"Huge Lake Would Result From APCO Dam." Roanoke, VA: *Roanoke World-News*, August 1, 1959.

Lugar, Norma. "The Men Who Saved Smith Mountain Lake . . . And Changed The World." Roanoke, VA: The *Roanoker*. March/April 1999.

Salmon, John S. and Emily J. *Franklin County Virginia 1786–1986: A Bicentennial History*. Rocky Mount, VA: Rocky Mount Board of Supervisors, 1993.

"Sand Starts Moving For Smith Mountain." Rocky Mount, VA: *The Franklin News-Post*, April 6, 1961.

Washington, Booker T. *Up from Slavery*. New York: Dover Publications, Inc., 1995.

Worley, Ozzie. "Smith Mountain Lake Swells To The Capacity Mark." Roanoke, VA: *Roanoke World-News*, March 7, 1966.

DISCOVER THOUSANDS OF LOCAL HISTORY BOOKS
FEATURING MILLIONS OF VINTAGE IMAGES

Arcadia Publishing, the leading local history publisher in the United States, is committed to making history accessible and meaningful through publishing books that celebrate and preserve the heritage of America's people and places.

Find more books like this at
www.arcadiapublishing.com

Search for your hometown history, your old stomping grounds, and even your favorite sports team.

Consistent with our mission to preserve history on a local level, this book was printed in South Carolina on American-made paper and manufactured entirely in the United States. Products carrying the accredited Forest Stewardship Council (FSC) label are printed on 100 percent FSC-certified paper.

MADE IN THE USA